THE COMPLETE GUIDE TO
VR & 360°
PHOTOGRAPHY

D1621547

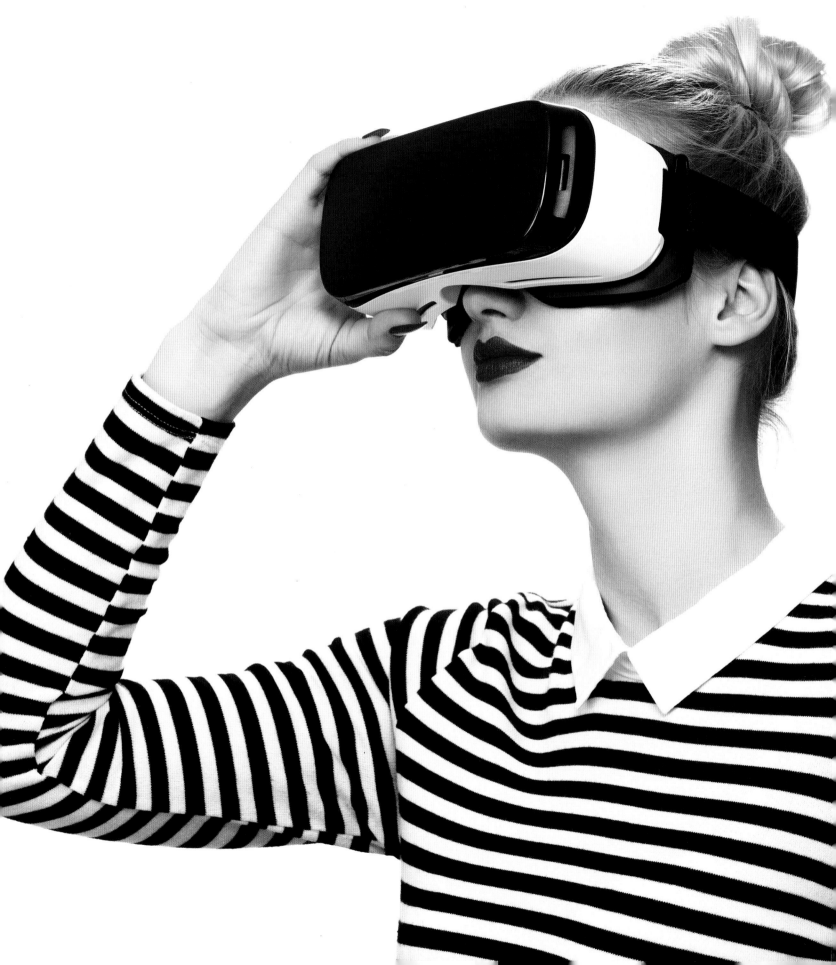

THE COMPLETE GUIDE TO VR & 360° PHOTOGRAPHY

AMAZING EXPERIENCES WHATEVER YOUR BUDGET 360°

JONATHAN
TUSTAIN

ilex

An Hachette UK Company
www.hachette.co.uk

First published in the United Kingdom in 2018 by
ILEX, a division of Octopus Publishing Group Ltd

Octopus Publishing Group
Carmelite House
50 Victoria Embankment
London, EC4Y 0DZ
www.octopusbooks.co.uk
www.octopusbooksusa.com

Distributed in the US by Hachette Book Group
1290 Avenue of the Americas
4th and 5th Floors
New York, NY 10104

Distributed in Canada by Canadian Manda Group
664 Annette St., Toronto, Ontario
Canada M6S 2C8

Publisher, Photography: Adam Juniper
Managing Editor: Frank Gallaugher
Publishing Assistant: Stephanie Hetherington
Art Director: Julie Weir
Senior Production Manager: Peter Hunt

ISBN 978-1-78157-539-0

A CIP catalogue record for this book is available
from the British Library

Printed and bound in China

10 9 8 7 6 5 4 3 2 1

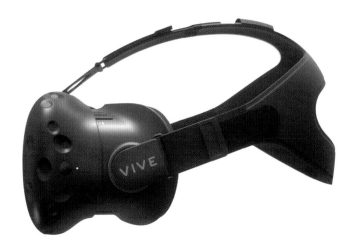

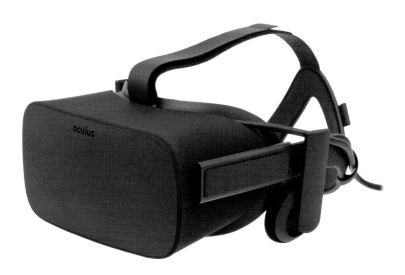

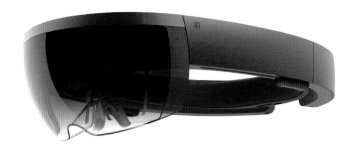

CONTENTS

INTRODUCTION

There's never been a more exciting time to dive into virtual reality. The industry, along with the world of 360° photography, has taken off in recent years, and whether you're simply curious about playing some VR games or want to investigate serious applications for your business, there's something for you here.

Of course, as with any blossoming technology, it's easy to feel overwhelmed by the constant iterations of high-end gear, innumerable apps and movies, and all the various possibilities. So, presented here is a lay of the land. Starting with a recap of how VR technology came about (it's been a long road!), we'll then cover the latest and most important gadgets and their various accessories. And we'll be sure to cover the full range, from cutting-edge high-end (and accordingly expensive) headsets, through to simple cardboard setups. Without getting too stuck down in nitty gritty details,

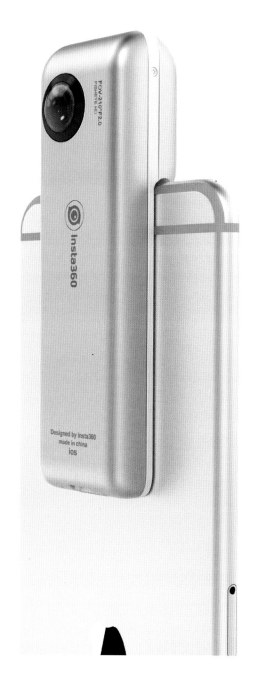

we'll also take a look under the hood at some of the essential science and terminology that makes it all work, as understanding the fundamentals helps make all the various systems make a lot more sense.

Then we'll dive into the creative possibilities, where the sky is the limit (though we'll go into space a few times as well). From beautiful animations to social environments and elaborate 360° cinematic achievements, exploring how other creators and artists are exploiting this tech expands your appreciation and, I hope, inspires you to think up your own experiments.

So, strap in, and let's see what virtual reality has to offer!

CORE ELEMENTS OF VR

A BRIEF HISTORY OF VIRTUAL REALITY

01

Once a concept of science fiction, the idea of virtual reality transporting people to multisensory make-believe environments has compelled scientists and researchers to try to bridge the gap between the real and unreal ever since the Victorian era.

1838 SAW THE launch of stereoscopic viewers. Looking at a photo through two lenses, people would see two slightly offset images of the same scene, just like we see in real life, creating an illusion of 3D depth.

This concept was later commercialized by the View-Master in the 1940s, a headset that offered "virtual holidays" when loaded with reels that featured stereoscopic images, often based around the theme of travel. The View-Master made a return in 2015 using the same principles, including the well-known side clicker, but with a smartphone insterted to deliver moving visuals instead of the static ones on the cardboard reels.

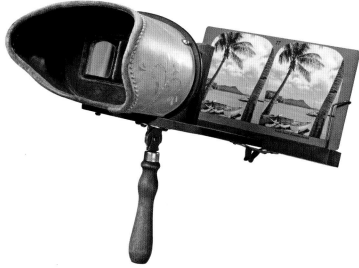

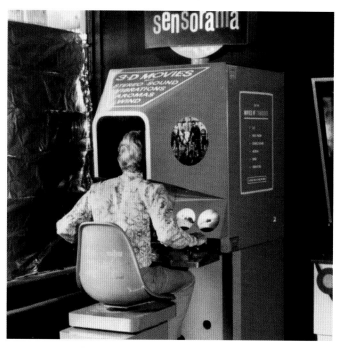

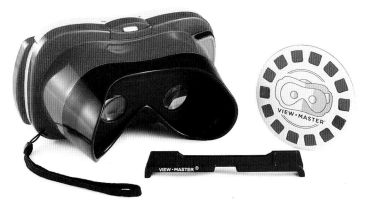

In 1962, Cinematographer Morton Heilig patented the Sensorama, a personal cinema kiosk that attempted to make the viewer feel like they were in the film. Patrons could watch one of the five specially shot films that were not only 3D, but enhanced with wind, vibrations, and even scents.

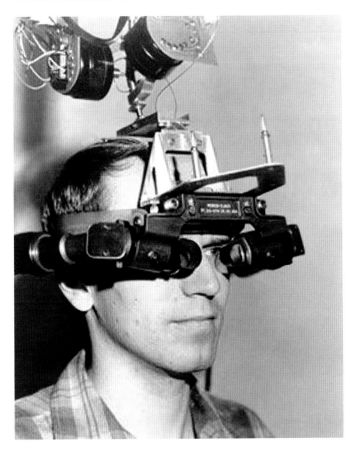

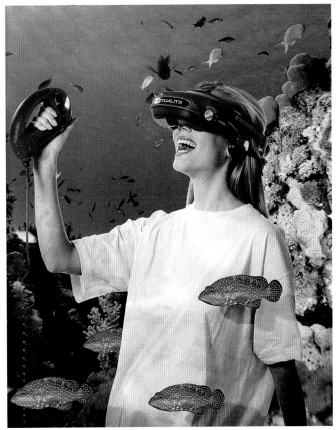

In 1968, Utah-based scientists Ivan Sutherland and David Evans invented what is widely considered to be the world's first virtual-reality headset. Its weight required it to be hung from the ceiling, earning it the name, "The Sword of Damocles." Two cathode ray tubes would display simple wireframe graphics in front of wearer's eyes, viewable from any angle thanks to a head sensor. The results were primitive but groundbreaking, and laid the foundation for computer-assisted virtual-reality experiences.

Also in the early 90s, a startup called Virtuality Group launched futuristic pods that included the Visette headset, a hand controller, and a range of first-person games. But the hype was short lived, and an initially enthusiastic public soon tired of the poor experiences characterized by slow, clunky graphics.

After headsets from Atari and Nintendo failed to gain traction, the 90s love affair with virtual reality was over. The technology was not ready to deliver on its promises. The internet and smartphones took over public interest and it looked like virtual reality was just going to be a passing fad.

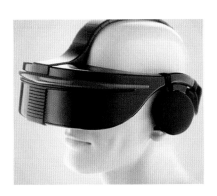

The short-lived Sega VR was revealed in 1993 and impressively featured head tracking, integrated stereo sound, and dual LCD screens. But Sega scrapped it due to concerns people would hurt themselves when wearing it.

Nobody knew it at the time, but virtual reality had only gone into hibernation, and it would actually be the internet and smartphones that would power the multi-billion dollar virtual-reality industry we see today.

CORE ELEMENTS OF VR

FROM FOV2GO TO OCULUS RIFT

FOV2GO was a project born out of the Mixed Reality Lab (MxR) at the USC Institute for Creative Technologies in Southern California. Professor and virtual-reality pioneer Mark Bolas led a research team who were exploring immersive systems for education, training, and entertainment through virtual reality.

THE TEAM REALIZED that smartphones contained the necessary technology to deliver virtual reality. Not only did they have a display and speakers for the visuals and audio, their internal accelerometers, gyroscopes, and magnetometers could be utilized to track where the viewer was looking, rendering the output accordingly in real time. All that would be needed was a simple low-cost attachment, similar to the Victorian viewers of the past.

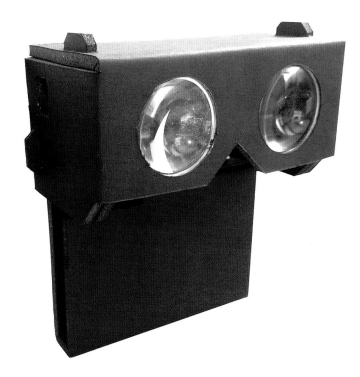

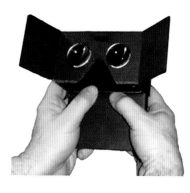

They developed the FOV2GO, a cheap, laser-cut foam mobile-phone holder, which incorporated two lenses to display a left and a right image to each eye when held to the face. Regarded as the first mobile-phone virtual-reality app, Bolas' team repurposed a scene from USC Game's first-person adventure *Tales from the Minus Lab*. Running on a regular phone, with a simple "viewer," for the first time in history, virtual reality was not only highly immersive, it was incredibly cheap.

One of Mark's students was Palmer Luckey, now the figurehead of modern virtual reality. Born in the same year *The Lawnmower Man* hit the cinemas, Palmer had been working on his own designs from his parent's garage, posting his progress on computer visualization forums. His first prototype, the PR1, put together with duct tape, was a heavy beast, with only 2D visuals, but it excited the imagination of 3D graphics pioneer and id Software founder John Carmack, who presented it at E3 in 2012 with a special VR version of *Doom 3*.

The enthusiastic response from the trade show inspired Palmer Luckey to launch a Kickstarter campaign for his Oculus Rift headset in 2012. Smashing all expectations, it raised almost

$2.5 million in pledges for his wide-field-of-view headset that could be powered by a regular PC. What was most revolutionary was its price: At just $300, not only was it more advanced than its predecessors, it was a fraction of the cost.

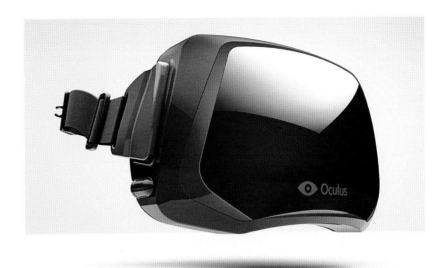

By now, the interest and commercial potential of virtual reality was huge. Other companies took note, and started to develop rival systems. HTC released the Vive, a headset that boasts full room-scale tracking; Sony developed the PlayStation VR; and Facebook acquired Oculus for $2.2 billion.

The concept of FOV2GO was also commercialized, with hundreds of phone-powered VR headsets hitting the market, like the Samsung Gear VR and Google with their hugely popular Google Cardboard.

The story of virtual reality may have started in the Victorian era, but after many false starts, we are now only just starting to discover virtual reality's true potential.

THE CINÉORAMA

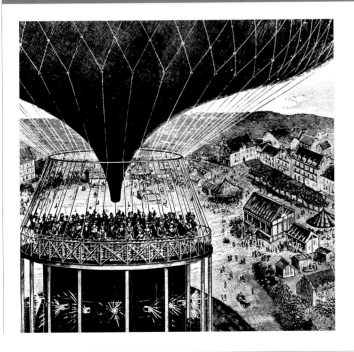

360° videos are highly popular on YouTube today, but the concept of immersive videos can be traced back to 1900. The Cinéorama synchronized 10 movie projectors to project a movie of a hot-air balloon ride over Paris, surrounding the audience with 360° panoramas. Unfortunately, the extreme heat of the projectors led to one worker fainting, and with the possibility of a deadly fire, it was closed down after a few days.

SMARTPHONE VIRTUAL REALITY

01

CORE ELEMENTS OF VR

Smartphone VR adaptors provide a low-cost entry point to virtual reality, as they leverage existing smartphone displays and tracking technologies.

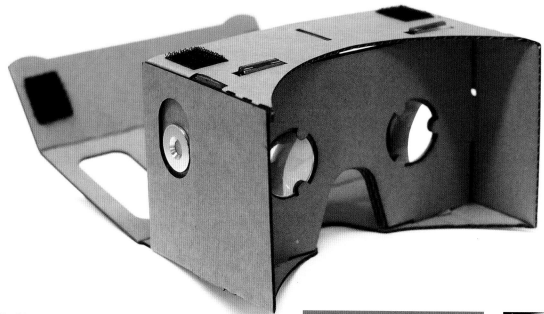

GOOGLE-CARDBOARD COMPATIBLE

There are literally hundreds of Google-Cardboard compatible headsets—passive devices that hold phones compatible with VR content available on the Apple App store and Google Play, most of which is free. Differentiators include whether they include an input mechanism (most Google Cardboard apps require the screen to be tapped to select an item or move forward for example), comfort, and field of view (the wider the better).

The official Google Cardboard app, available for iPhones and Android phones, is a great starter app. Not only does it include a spectacular intro to VR called *Arctic Demo*, it also includes several utilities such as Google Earth, a Photo Sphere viewer, and 360° tours. Another great resource is wearvr.com, which lists the very latest experiences.

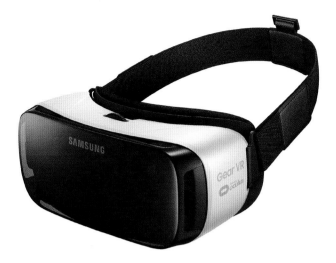

GOOGLE DAYDREAM VIEW

The Daydream View is a passive headset designed for specific Android phones that feature built-in custom sensors designed for silky-smooth tracking. Included is a controller that tracks the motion of your hand and there are a range of purpose-built experiences available such as Netflix and a version of YouTube that features shared rooms, where viewers can watch 2D and 360° content together, commenting via voice chat. Google has also partnered with IMAX so that Daydream View owners can watch certain IMAX 3D movies for free.

SAMSUNG GEAR VR

This is an active adapter that fits to Samsung phones and adds an IMU (Inertial Measurement Unit) for smoother head tracking than what can be achieved by the phone itself. When connected, an optimized version of Oculus Home is launched with over 1000 experiences to choose from. You can also link the Gear VR to your Facebook account, where you can live stream your VR gameplay. There is a finger-sensitive touchpad that allows you to interact with apps in a limited way; however, for greater interaction, Samsung also offer a motion-controlled controller.

FANTASTIC BEASTS

There is a large range of exclusive apps available for the Daydream including J. K. Rowling's *Fantastic Beasts,* where you can meet and interact with beasts, cast spells, and immerse yourself in the magic using a wand.

ZEISS VR ONE CONNECT

This headset, from master optics manufacturer Carl Zeiss, still uses your phone like the others, but is unique in that it can stream Steam VR games from your PC via a USB cable. It also includes two motion-sensitive wireless controllers.

HEAVYWEIGHT VR GLASSES

For the ultimate virtual-reality experiences that money can buy, there are multiple high-end headsets to choose from, but the market is dominated by three heavyweights—the Oculus Rift, Sony PlayStation VR, and HTC Vive, all of which have strong developer support.

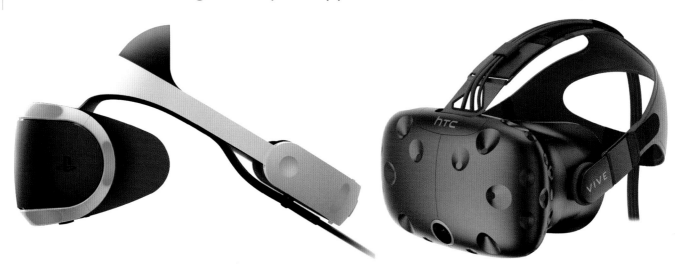

PLAYSTATION VR BY SONY

The least expensive of the three, Sony's PlayStation VR is powered by the existing PlayStation 4. The headset features nine LEDs that are tracked by the PlayStation Camera to locate the user's head orientation and position with sub-millimeter accuracy. The camera can also track hand movement when holding the DUALSHOCK Controller, the PlayStation Move motion controller, or the purpose-built PS VR Aim controller, designed for shooter games. The PlayStation VR is capable of a high 120Hz refresh rate, and its display features more subpixels than the others, reducing the "screen-door" effect despite its lower overall resolution. Non-VR games can be played in "Cinematic Mode," which renders the content on a simulated projection screen in a 3D space.

THE HTC VIVE

Packed with over 70 sensors, the Vive is technically the most advanced headset of the three, compatible for both PC and Mac. It requires a very powerful computer to run its dual full-HD screens, and supports room-scale tracking so you can walk around in a space up to 15×15 ft (4.6m^2). The base stations also track two included hand controllers that feature haptic feedback, adding an extra sense of presence when picking up or manipulating objects. Vive VR experiences can be accessed via Steam or Viveport—a Netflix-style subscription service.

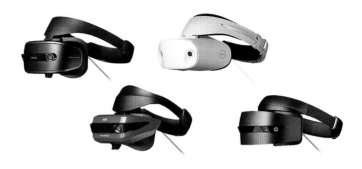

OCULUS RIFT

The headset that kickstarted the revolution, the Oculus Rift is compatible with PCs and Macs and is a more compact setup than the Vive. A desk-mounted infrared sensor tracks light from multiple LEDs on the headset for precise low-latency positional tracking. For input, motion-tracked Oculus Touch controllers allow you to see your hands as you move them through the virtual space. Oculus also offer a lower-cost headset called the Oculus Go which features an integrated screen (so no phone required), spatial audio, and a wireless controller.

WINDOWS MIXED REALITY

This refers to a confusingly named collection of virtual-reality headsets (so not mixed reality in the sense of the HoloLens—see page 18) from the likes of Acer, HP, Dell, and Lenovo. Developed with Microsoft, they can track your position at room scale without any external sensors, utilizing some of the technology found in the Microsoft HoloLens. They can run on older computers using integrated graphics, albeit at 60fps, but in Ultra mode (which requires similar computer power to running a Vive or Rift) they can run Steam VR games.

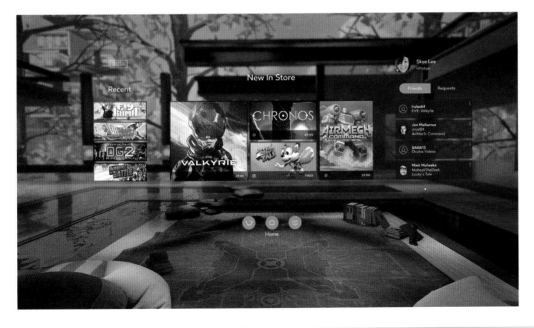

OCULUS HOME

This is a virtual-reality portal where people can purchase and launch titles within the headset itself.

HIGH-END MIXED REALITY

01

Virtual reality has a companion known as mixed reality (MR); so what's the difference? Virtual reality is all about immersion, where you experience a 100% digital world that obscures your entire vision. Mixed reality also projects digital assets into your view, but anchors them in your real world, as if they were part of and interacting with it.

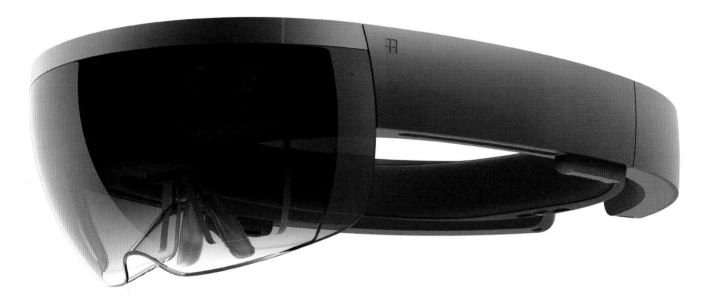

WITH MIXED REALITY, your living room could become the stage of an interactive scene from an action movie, or you could enjoy a Netflix movie with a distant loved one sitting on your sofa, as a hologram. MR holds a lot of promise for the future in terms of how we interact with people and the world around us, giving us the possibility of on-demand personal assistants or altering the look of our home based on our mood. Once the technology becomes the size of a contact lens, outdoor games such as *Pokémon Go* and *Father.io* will be transformed into hands-free real-world experiences.

MICROSOFT HOLOLENS

At the top end of the scale is the Microsoft HoloLens—a highly impressive headset that works by scanning the room it is in and "augmenting" virtual assets into it, which can then be interacted with via voice control and hand gesture. It is well supported with applications ranging from gaming to a holographic version of Skype. In the concept *Ghost Girl*, the user experiences a ghost in their real house, whom they have to work with to solve the mystery of who murdered her.

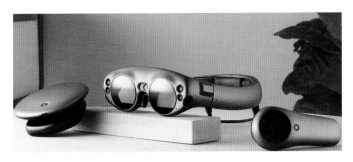

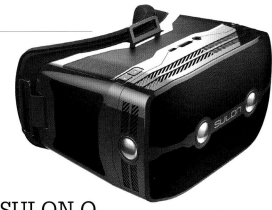

MAGIC LEAP

Magic Leap's wearable cinematic-reality technology uses something called a digital light-field signal that mimics how we see in the real world to overlay 3D graphics in the view of the user. Looking more akin to a pair of glasses, the computer power is housed inside a belt pack. The company is working closely with movie studios to bring well known IP to life including that of Industrial Light & Magic.

THE SULON Q

A hybrid wireless virtual- and mixed-reality headset, the Sulon Q uses spatial mapping to switch from augmenting objects in the real world to fully immersive virtual reality. In the *Magic Beans* demo (below), a beanstalk grows out of the floor in front of you (mixed-reality mode) before a giant smashes through the ceiling and lifts you up to his face (virtual-reality mode).

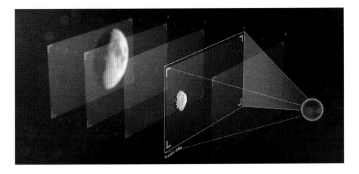

AVEGANT GLYPH

Avegant Light Field Technology delivers ultra-high quality, detailed virtual objects that appear to be right at your fingertips, resulting in a more realistic and interactive mixed-reality experience. Light Field Technology uses multiple focal planes to display any number of virtual objects, each with the correct focal depth, matching the focus of the physical, real-world objects around them. This is distinct from a fixed-focus waveguide display, which is optimized for displaying objects at a focal distance beyond arm's reach. What is even more remarkable is that retinal projection beams the images directly into the back of your eyes so there is no pixelation or "screen door" effect.

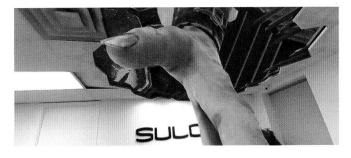

AFFORDABLE MIXED REALITY

The mixed-reality headsets discussed so far can cost thousands of dollars. Fortunately, there are lower-cost (albeit less-advanced) options available on the market.

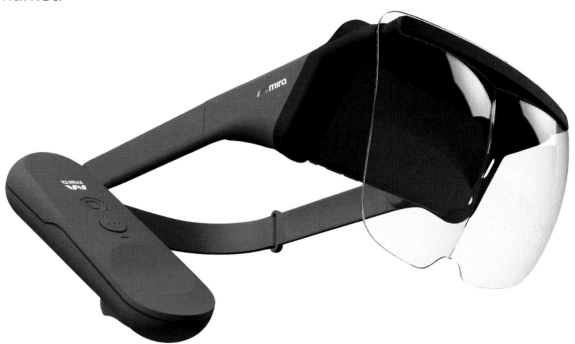

ZAPBOX

The ZapBox by Zappar uses your phone to augment virtual objects in your real world. Fiducial markers called point codes can be attached to various surfaces such as tables, walls, or the floor, which the app then scans, mapping the space in the room using computer vision. Once your phone is installed into the ZapBox, the app splits the front-facing camera image into two, one for each eye, and using the depth information, cleverly shifts each image so both the augmented objects and the real world appear merged in stereoscopic 3D. Two controllers are tracked and converted into virtual objects such as a drum stick, paintbrush, or golf club, depending on the application. By using different ZapBox kits, you can collaborate or play with up to four people on the same experience, both in the same room or remotely with players in different locations.

MIRA PRISM

This device takes a different approach. It connects to the user's iPhone but reflects the screen content onto a transparent visor that he or she looks through to see 3D images overlaid in the real world. It has a 60° field of view.

LENOVO MIRAGE

Lenovo's Mirage is a hybrid VR/MR headset powered by your phone, featuring a clear front visor and internal lenses. A beacon placed on the floor is tracked by the headset's sensors to anchor 3D objects within your real-world view. It was launched as a *Star Wars™: Jedi Challenges* pack and included a Lightsaber-themed controller and an app that simulated lightsaber training against Sith lords Kylo Ren and Darth Vader, epic space battles, and, of course, Holochess, all overlaid in the user's real environment.

MR BOARD GAMES

Mixed reality is all about the fusion of the real and digital, and physical board games are a perfect candidate for digital makeovers. *KOSKI* is a board game that includes real wooden blocks that can be connected in many different ways via magnets. When viewed through an iPad, the app recognizes the objects and augments hidden characters, worlds, and digital interactive gameplay according to the structures the player creates.

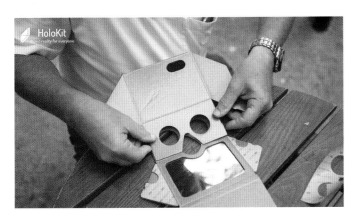

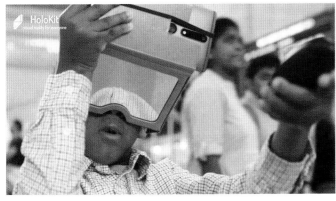

BUILD YOUR OWN MR HEADSET

HoloKit by Amber Garage is a flatpacked open-source MR headset made from cardboard. When a phone is inserted, a pair of mirrors reflects the display onto an angled, semi-transparent fresnel lens, so you see both the image and the world behind it.

It uses inside-out tracking to monitor the changing perspective of the world through the phone's camera in order to position the 3D objects. Full instructions how to build one can be found at holokit.io.

LATENCY

In the real world, when we move our head, our perspective of the world changes accordingly and instantly. It is how we know where we are in space at any given time. For virtual or mixed reality to trick our brains into believing what we are seeing is real, there needs to be minimal time between the movement of our head, and the graphics updating to our new view.

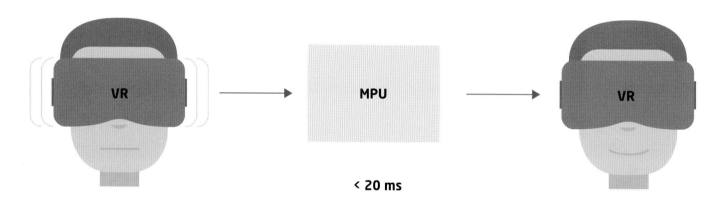

THIS TIME IS called motion-to-photon latency and the lower it is, the better. Any perceivable delay where the inner ear registers something different to what the eyes see can lead to motion sickness. It is generally regarded that virtual-reality latency should be no greater than 20 milliseconds (ms), or 20 thousands of one second, but this is no easy task.

The multiple sensors tracking your head movement have to determine the exact position of where your head is looking, transmit that data to the computer or phone's GPU to process, and render out a left and right image to the display. In the case of the Vive, for example, that is switching on 2,592,000 pixels (or 1,296,000 for each screen), all at a speed faster than 20ms. The time it takes to draw an image on the screen is 16.7ms alone, so researchers have been

developing clever techniques to get close to the magic number of 20ms or less. Faster chips are being developed, but in the meantime, there are various software techniques to speed up latency, one of which being Asynchronous Timewarp (ASW) which improves latency by predicting what the next frame will be.

Let's say you look forward. An image of that view is generated. Now you start to turn your head. Rather than display the original view (which would take 16.7ms to draw on a screen), it registers your new view data and mathematically "warps" or distorts the original view with that very slight change, "jumping ahead" 16.7ms. This happens very fast for each frame, bypassing all the heavy CPU and GPU work required if each had to be drawn from scratch.

Google Daydream-compatible phones such as the Google Pixel and Samsung S8 feature native chips designed for low-latency virtual reality; but Microsoft has developed a technique called FlashBack, which enables low-latency movement on cheaper, less-capable handsets. This reduces latency by up to 15 times by pre-rendering and caching all possible images that a VR user might encounter offline and storing those in the phone's memory. During gameplay, FlashBack quickly looks up images that the user should be seeing instead of rendering them in real time.

Looking to the future, latency will need to be reduced even further for AR and MR where virtual objects need to be connected to real world objects. Any slight discrepancy would lead to the illusion being reduced.

ANTICIPATING THE PERIPHERY

In the scene below, the central portion may be all you see at a given moment, but the surrounding area can be rendered ahead of time, stored, then recalled from memory. This process is faster than rendering in real time.

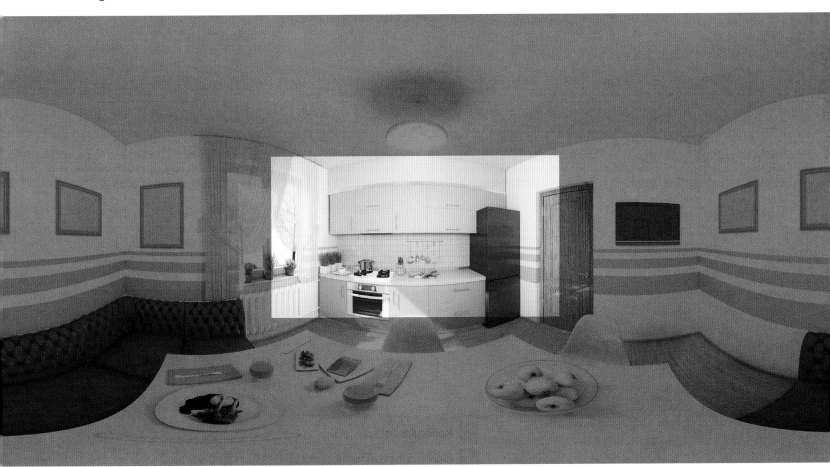

FIELD OF VIEW

Field of View (FoV) describes everything you see at a given moment, from the very center of your fovea (the most central part of your eye) to the very edge of your peripheral vision. FoV is measured in degrees, and humans see between 200° and 220°. Face forward and wiggle your thumbs up in front of you at arm's length. Now move your arms to the sides, continuing to move your thumbs. You should still see them wiggling even when they reach parallel to your ears, although in very little detail.

RELEVANT TO VIRTUAL reality is your binocular field of view, which is about 114°. This is the range you can see in 3D and where the views from your left and right eyes overlap. With the left and right eyes seeing the same image at slightly different angles, you can perceive depth. Repeat the exercise above, but this time close your left eye. You will notice your left thumb will disappear sooner, as it disappears out of the binocular range. Our 2D peripheral vision is very important to us, as it is where our eyes are most sensitive to motion. This was particularly useful for humans when we hunted for food and needed to be aware of fast-moving predators surrounding us.

In virtual reality, the higher the FoV, the better. The VR heavyweights support about 110°—only 55% of the average perceivable FoV, although enough to cover most of our binocular vision. This can create a sense of looking down a tunnel, as our peripheral vision notices the sides of the headset.

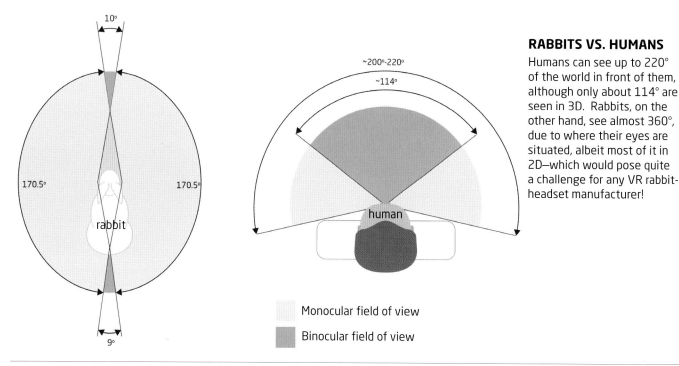

RABBITS VS. HUMANS
Humans can see up to 220° of the world in front of them, although only about 114° are seen in 3D. Rabbits, on the other hand, see almost 360°, due to where their eyes are situated, albeit most of it in 2D—which would pose quite a challenge for any VR rabbit-headset manufacturer!

Monocular field of view

Binocular field of view

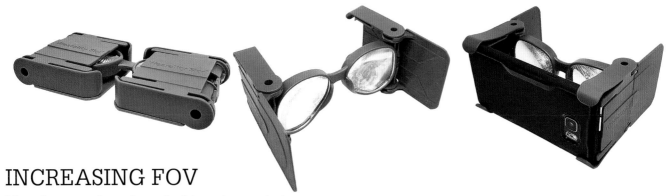

INCREASING FOV

Manufacturers have been looking at ways to increase FoV. Wearality has developed a system (shown above) that uses Fresnel lenses to reach 180° by using "double convergent Fresnel lenses to create a collimated light field," stretching the image.

The company Starbreeze has gone one step further with a headset (shown right) that features two 1440p panels mounted side-by-side at an angle. They have developed a set of custom Fresnel lenses that make the image appear to wrap around your face. This offers a whopping 210° field of view at 5K resolution.

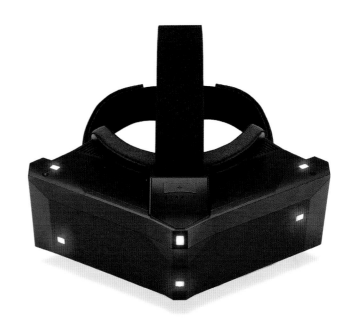

Microsoft has also developed the "sparse peripheral display" (shown below), which emulates up to 170° FoV using rings of peripheral LEDs around each lens in the VR headset. These are illuminated with the most dominant color on the side of the screens, effectively "stretching out" the image into the user's peripheral vision.

SCREEN RESOLUTION & REFRESH RATES

CORE ELEMENTS OF VR

VR headsets tend to use OLED (organic light-emitting diode) panels because they have a very fast response time—that is, how fast they can draw a new image from one to the next. These panels consist of arrays of pixels, each emitting light. When viewed from a distance, your brain merges the pixels into a complete picture.

RESOLUTION IS MEASURED by the number of columns multiplied by the number of rows. For example, a 1080p HDTV consists of 1920 pixels horizontally and 1080 vertically, a total of 2,073,600 pixels (or 2 megapixels), regardless of its screen size.

The Vive and Oculus Rift feature two 3.5-inch OLED screens, each of which offers 1080 x 1200-pixel resolution for each eye, with a total resolution of 2160 x 1200. But what would be the ultimate resolution for the human eye to not know the difference between real and virtual?

Scientist Roger N. Clark famously calculated a display would need 576-megapixels to fill our entire field of view and be indistinguishable from how our eyes see the real world.

However, our eyes do not have a consistent "resolution" across our field of view. Where we see most detail is via our fovea, an area at the back of our eyes that holds about 50% of our light cells, and is responsible for only 2% of what we see. Even reading this book, you will notice the words are only clear in a very small part of your vision, hence the need to scan your eyes across the sentences.

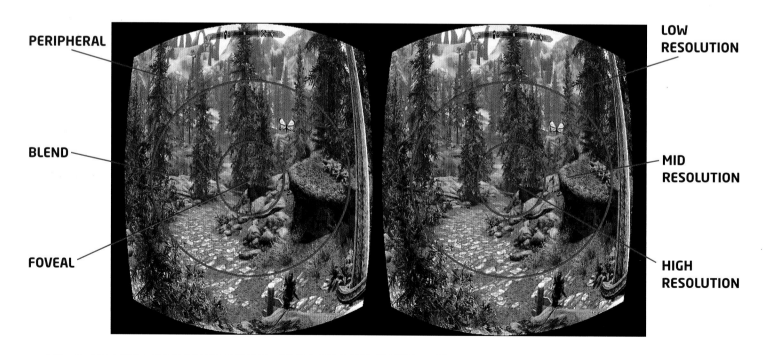

PERIPHERAL

BLEND

FOVEAL

LOW RESOLUTION

MID RESOLUTION

HIGH RESOLUTION

Foveated Rendering is a technique that exploits this fact, where ultra-high resolutions are displayed only in front of the fovea, which is achieved using eye-tracking technology. This also reduces the computing power required, as there is no need to render high resolutions for the peripheral vision.

Varjo has combined a context display, focus display, optical combiner, and gaze tracker into a "bionic display" that displays full HD resolution precisely where the fovea is looking at a given time. By delivering a full-HD image to wherever the fovea is looking, rather than across the entire screen, Varjo's system is comparable to a 70-megapixel display, versus the 1.2 megapixels per eye for the Oculus Rift and HTC Vive. In the meantime, companies are packing in ever greater numbers of pixels into small screens. Samsung has produced a display capable of 855ppi (pixels per inch), which is 3.4 times that of the HTC Vive and Oculus Rift.

FRAME RATE

In virtual reality, the frame rate is commonly measured in Hertz (Hz), that is, how many images are shown to the eyes per second. If shown fast enough, our brains merge the images together so they appear moving, in a process known as "persistence of vision." Just as cartoon animations are a series of individual drawings, virtual reality draws each image at a rate we perceive as fluid motion.

Both the Oculus Rift and HTC Vive have a 90Hz refresh rate and the Sony PlayStation VR can support up to 120Hz. 90Hz is regarded as the minimum required to create a strong sense of presence without generating nausea.

BASIC TRACKING

Fluid tracking of your head and body movement is fundamental in delivering a lifelike VR experience. If you turn left, you want to see the world turn left. If you kneel down and look at the floor, you want to see the floor move toward you. So how does a VR headset know exactly where you are and what you are looking at?

THE MOVEMENTS DESCRIBED above are known as Degrees of Freedom or DoF, and it is the job of sensors in the phone (for mobile VR), headset, controllers, and outside space that register your movements and send those coordinates to a CPU, which processes the data so the GPU can display matching graphics. The most basic form of tracking is known as 3DoF or 3 Degrees of Freedom, also referred to as roll, pitch, and yaw.

Mobile VR such as the Google Cardboard and Gear VR work on a 3DoF or orientational system; that is, they can translate the movement of your head only, on a fixed axis. Rotate your head, and that is yaw. Tilt your head left and right, and that is roll; turn to the left and right, and that is pitch.

To track these three movements, a sensor inside the phone, called an Inertial Measurement Unit (IMU), is used, which features an accelerometer, gyroscope, and magnetometer.

Accelerometers measure how fast something is speeding up or slowing down and relies on gravity as a reference point. However, the accelerometer cannot measure yaw, so a gyroscope within the IMU measures rotation and how fast something is spinning about an axis. Output from the gyro is quite smooth, and very responsive to small rotations, but can suffer from drift.

A magnetometer is used to generate a fixed reference point based on the magnetic field, to keep things stable. The data from all three measurements is combined together using a technique called "sensor fusion," which VR developers can then use to create experiences that change the view as you move your head.

Most modern Android phones and all iPhones contain IMUs and are therefore compatible with Google Play and Apple App store VR apps. Dedicated IMUs are also used to sense the motion of the Google Daydream wand and Gear VR controller. While the IMUs in regular phones offer a reasonable VR experience, they cannot match the accuracy of the dedicated VR IMUs. Therefore, the Gear VR features a custom IMU which is activated when a compatible phone is connected via its micro-USB port. This overrides the phone's inferior IMU with faster gyroscopes and software techniques such as asynchronous timewarp to reduce latency to less than 20ms, the same as the Oculus Rift. Google Daydream-compatible phones, such as Google Pixel, feature faster IMUs to deliver Gear-VR-quality experiences.

But there are limitations. You can look up, down, left, and right, but it will not sense you ducking or walking around the room. That requires more complex tracking known as 6DoF or "positional tracking," which we will explore next.

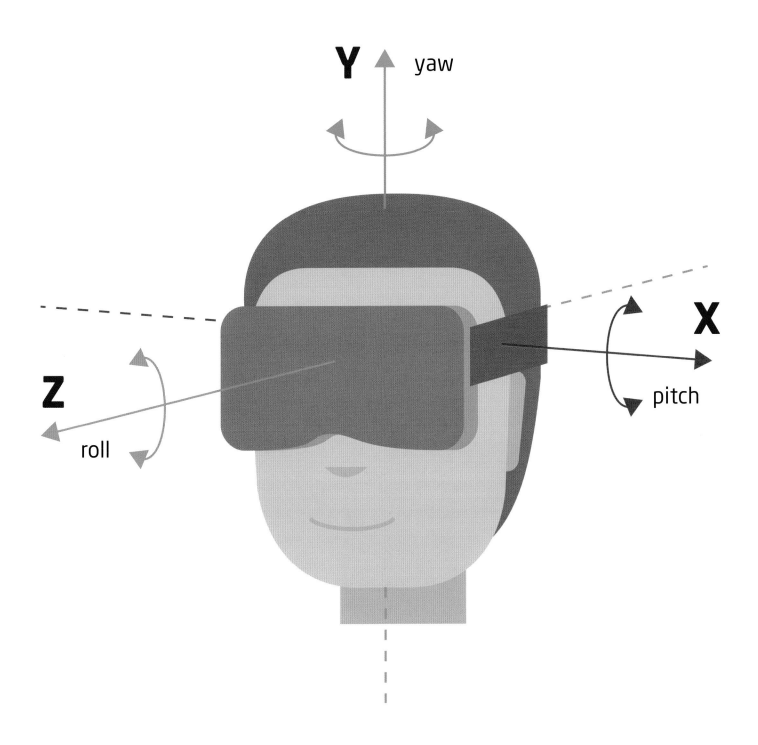

OUTSIDE-IN POSITIONAL TRACKING

01

CORE ELEMENTS OF VR

Positional tracking is essential for delivering an ultra-realistic VR experience. In real life, we move forward and backward, left to right, and up and down. In virtual reality, we might wish to slide left to look behind a rock, crouch down to avoid enemy fire, or lean forward to get a closer read of a clue. This is known as 6DoF or positional tracking. Let's explore the most common method, which is known as outside-in tracking, where sensors on the outside of the headset are required to locate the user in space.

OCULUS' CONSTELLATION

The Oculus Rift uses an optical system known as Constellation. Positioned on the headset and Touch controllers are an array of infrared LED lights (hence the name), the exact configuration of which is understood by the software. Each one blinks in sequence at 1000 times per second which is picked up by an infrared sensor stationed in front of the user. Synced to the PC, so the computer knows which dot is illuminated and when, the software can draw an accurate 3D model of where the headset is. To judge how far away the headset is from the camera (its depth) it registers the size of the LEDs—the smaller they are, the farther away they are.

SONY VR TRACKING

The PlayStation VR requires the PlayStation 4 Camera, which uses 3D depth-sensing technology to precisely track a player's position in the room as well as their hands when holding the Move controllers with a tracking range of 6 feet (2m). At 1000 times per second, the Camera tracks nine visible LEDs on the front and back of the headset as well as a diffused LED on the DualShock 4 (DS4), PlayStation Move Motion (PS Move), or PlayStation VR Aim (PS VR Aim) controllers.

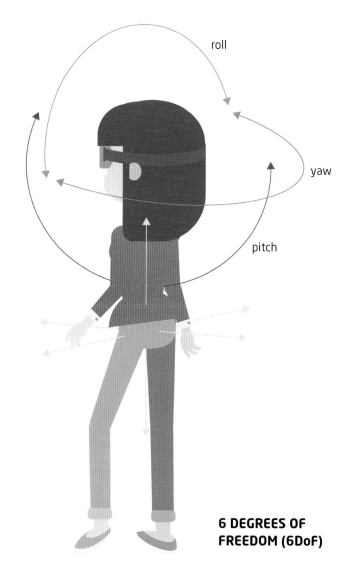

6 DEGREES OF FREEDOM (6DoF)

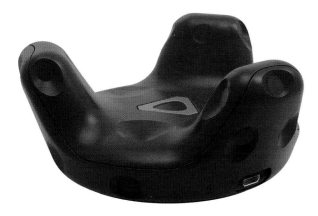

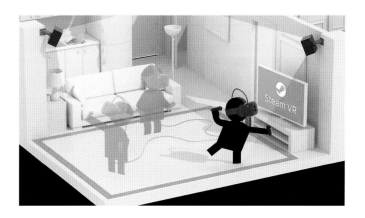

HTC VIVE TRACKING

The most sophisticated of them all, Vive offers room scale tracking—meaning you can stand up, crouch, jump and even lie down in a $15ft^2$ ($4.6m^2$) space. It uses base stations called "lighthouses," (above) which are located around the room. In a fast sequence, they output a flash of infrared light picked up by the controller and headset IR sensors. This is called Optical Sync. Next, a spinning rotator reflects out a streak of laser light across the room. This happens incredibly fast, with each beam of light scanning the room at 5.5 times the speed of sound.

On the headset itself are 70 photodiodes (devices that convert light into an electric signal) that sense when the laser light hits each of them and measures the time of impact between each sensor. Since the sheet of laser light is rotating at a constant velocity, the angle from the base station to each light sensor can be computed by measuring the time from the sync light pulse (time zero) to the time when the plane of light hits each sensor, building up a precise position of where the headset and controllers are.

CAT TRACKER

The Vive tracker add-on can be attached to anything that needs to be tracked. The developers at Triangular Pixels found their pet cats would often walk into the game play areas during testing. By attaching a Vive tracker to their feline companions, they could avoid unfortunate mishaps by seeing a virtual representation of their cat in the VR space!

NEXT-GENERATION TRACKING

As impressive as the technology is, the outside-in positional tracking discussed on the previous pages can be restrictive, as you need to remain in the space where the sensors are. What if you wanted to experience virtual reality house-scale, campus-scale, or even city-scale? This is all possible with inside-out tracking, and it is set to liberate VR and MR experiences.

INSIDE-OUT TRACKING HAS its roots in autonomous drones, robots, and car research—objects that need to simultaneously locate where they are and build up a picture of the environment they are in. Apply that technology to a headset, and you are free to experience true positional tracking without the need for any external sensors.

Inside-out tracking is perfect for MR too, where virtual objects need to accurately coexist with physical objects. If you want to be shooting an armed mutant gecko scuttling across your living room walls, using a sofa to protect you from attack, your headset needs to know exactly where the wall and sofa are.

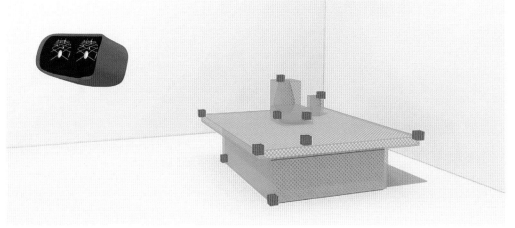

WORLDSENSE

Google's solution is called Worldsense and is incorporated into untethered standalone headsets from Lenovo and HTC, which feature two forward-facing cameras. These cameras work in tandem to detect edges in the environment and use them as reference points, so the headset can tell how far you've walked in real space and translate that into virtual motion as well.

Inside-out tracking is achieved in several ways, but generally, it is a combination of depth sensing and motion tracking done in real time. Depth sensing scans the real things around you and builds 3D virtual models from that.

Some systems project a pattern of infrared dots known as a structured light pattern (invisible to people) which illuminates the contours of objects. An infrared sensor then reads the pattern of dots and builds up a 3D image with depth by analyzing the displacement of the dots and their size. For example, on near objects, the dots are larger and more spread out compared to a denser pattern on farther-away objects.

Another method is called Time of Flight, which gauges depth by measuring the time it takes to transmit a beam of infrared light and capture its reflection—the longer it takes, the farther away the object is.

Thirdly, stereo cameras can capture the scene and, using triangulation methods, depth can be obtained, as used by Google's WorldSense (opposite).

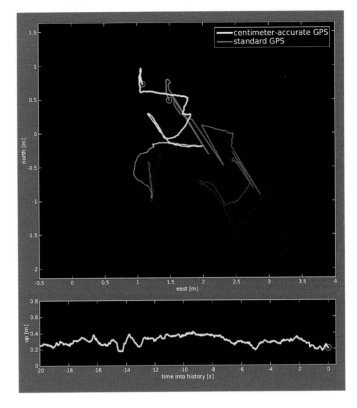

CITY-WIDE POSITIONAL

Radiosense has developed a centimeter-accurate GPS-based positioning system that could allow outdoor positional tracking for VR headsets with GPS. With just a mobile antenna, GPS satellites thousands of miles high can even register when a VR headset-wearer jumps.

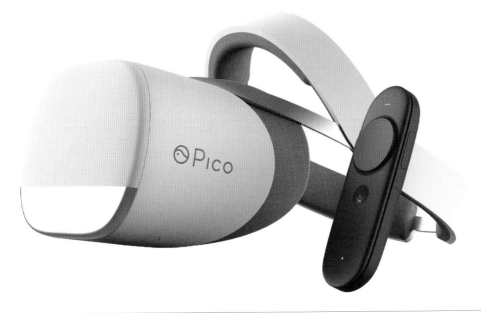

PICO NEO CV

This device combines the usual gyroscope and accelerometer data with a camera looking at the outside world, using computer vision-processing to extract the user's position.

FEATURE TRACKING

Eye contact, our facial expressions, and how we gesticulate are important ways we communicate and interact with the world. So, for a true sense of presence in VR, there are peripherals available to complete the picture.

HAND TRACKING

The controllers we have discussed so far only track where your hands are holding them in space—they do not track the dexterity of your individual finger movement. To naturally pick up a ball or operate a virtual string puppet we need individual finger tracking.

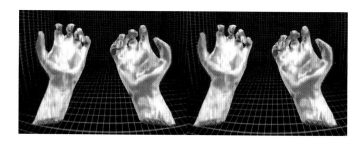

OCULUS

Oculus has showcased glove technology which allows you to "type" in thin air, and even shoot webs like Spider-Man. Pebbles Technologies has taken this realism even further with technology that shows your real hands in virtual space, complete with your skin color, and even any scars!

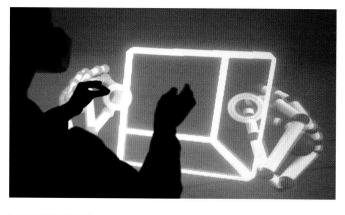

LEAP MOTION

This system can track fingers without the need to wear a glove. Attached to VR headsets, the module uses two cameras and three infrared LEDs to project and track infrared light against your hands, generating a real-time point cloud used to construct skeletal representations of your hands which can interact with 3D objects.

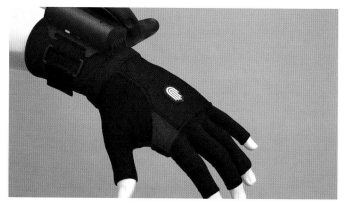

THE HI5 GLOVE

A wireless VR glove for the Vive by Noitom, this is one of several glove options. Inside are six 9-axis IMU sensors on each finger that transmit movement data wirelessly to the Vive to animate matching hand and finger movement in real time.

EYE TRACKING

Eye tracking, as featured in the Fove headset, opens even more possibilities. A blink can act as a trigger or initiate a task. A gaze could guide the trajectory of an object. Eye tracking also enables more realistic experiences as it closer matches the way we see the world. Our eyes shift focus all the time, and Fove's eye tracking caters for this, shifting focus according to where you are looking, a feature known as Dynamic Depth of Field. It also means characters in VR experiences can be better engaged with. In Fove's game *Sword Art Online VR*, female protagonist Asuna (shown right) acts as a concierge to new users. The experience leverages the headset's eye-tracking capabilities to give Asuna the ability to recognize when you are looking at her. Looking at her right in the eye will elicit a smile, but ignore her and she'll get upset.

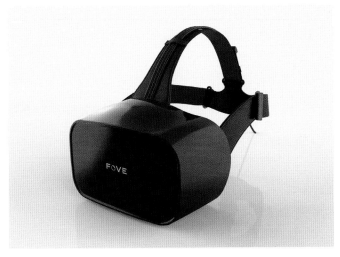

To track one's eyes, the eyes are illuminated with infrared light that reflects off the surface of the cornea. As the pupil does not reflect light, a camera pointing toward the eyes can distinguish the location of the pupils (and therefore the gaze) by registering where the light is not being reflected. Infrared is used because it is not visible to humans and therefore will not distract from the experience.

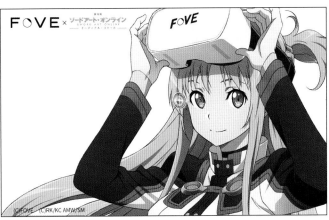

FACE TRACKING

There are even some headsets that can track your entire facial expressions. Emteq's Faceteq uses a range of biometric sensor techniques including electromyography (EMG), electrooculography (EOG), heart rate, and more, tracking the electrical current generated in the movement of facial muscles. Such headsets are ideal for realistic avatar interaction in social VR experiences (see pages 104-111).

HAPTICS

Your skin is your largest organ. In every square centimeter, there are about 200 pain receptors, 15 receptors for pressure and texture, and 7 for temperature. The sense of touch is very important in our daily interactions with the world around us, and therefore very vivid. Imagine holding an apple; you can probably "feel" its waxy smooth surface, contours, and weight.

IN THE PURSUIT of ultra-realistic virtual experiences, recreating the sense of touch is vital. If you lifted up a virtual apple and could not feel it, the sense of illusion would be instantly lost. The artificial sense of touch is known as "haptics," and such feedback is being incorporated into gloves—a natural place to start, considering that our hands are our primary organ for feeling the world around us.

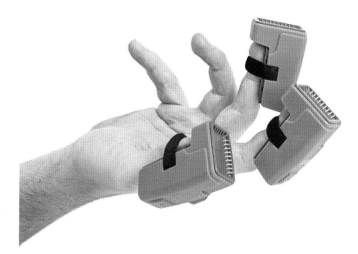

VR Touch (shown right) is a wearable device that is not so much a glove, as individual devices you attach to the end of each finger. Wearing them, if you see a button in VR and press it, you can feel the click of the button. With more fingers connected, greater touch fidelity can be achieved.

TRY IT FOR YOURSELF

Haptic Technology Immersion has released an app called *Content Portal* that combines video with timed haptic feedback. For example, in the hard-hitting campaign film *Decisions* by alcohol producer Diageo, the viewer is thrown into the dramatic consequences of drunk driving, with the phone vibrating to simulate the rumble of the road and the impact of the final crash.

WIRELESS HAPTICS

Ultrahaptics uses sound to deliver high-definition feelings of touch without wearing gloves via a phased array of ultrasound transducers that create tactile focal points. These receive patterns of objects from a PC, and can then deliver the perfect amount of force, location, and phase to recreate the shape of an object as the user moves their hand across it.

Creating a focal point using an array of transducers.

Volumetric haptic shapes projected using ultrasound.

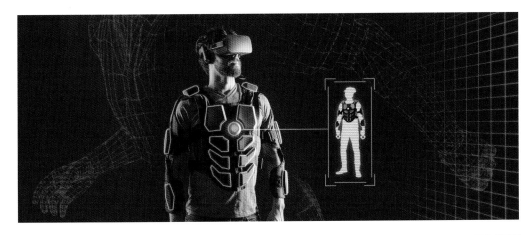

A FULL-BODY EXPERIENCE

The Hardlight VR suit can deliver real physical sensations throughout the body in response to VR games. It has 16 unique haptic feedback zones, or actuators, targeting every muscle group, and they can act independently of one another.

In cyber ninja shooter *Sairento VR* by Mixed Realms, the Hardlight VR suit delivers "whooshing" sensations as the player leaps, the impact of a bullet, and the thud when they land. When the player enters Focus Mode, a *Matrix*-style slow-motion sequence, the suit simulates a rapid heartbeat effect.

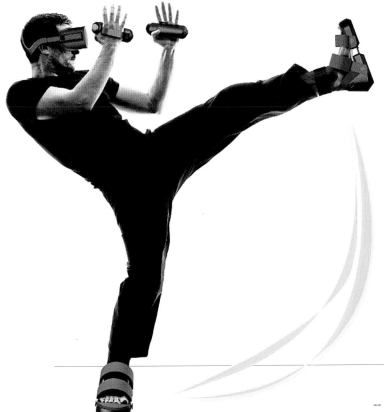

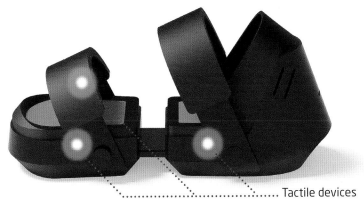

Tactile devices

THESE BOOTS ARE MADE FOR WALKING

Your feet aren't left out either. The Taclim shoes from Cerevo are tactile devices that generate the sensation of walking across various terrain such as sand or grassland, or even kicking an enemy, with a soft impact for hitting his body or a hard impact for hitting a shield.

LOCOMOTION

In the real world, if we want to move from A to B, we can walk. Try walking with a headset on and you could soon find yourself in the hospital with a furniture-related injury! There are various software techniques and specialist hardware that allow us to span vast distances in virtual worlds while remaining within our small physical-world constraints.

AT THE SIMPLEST end, some Google Cardboard experiences are compatible with regular Bluetooth gamepads, but most use software techniques such as "autowalk," as in *Refugio Space Station 3D* (shown right). When looking down at a footprint logo, you activate an automatic forward motion. Look at it again and you will stop.

"Bobbing" is another technique where you literally walk on the spot. The natural bobbing motion of your head is translated into lateral movement in games like *Gravity Pull*.

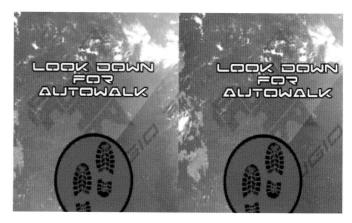

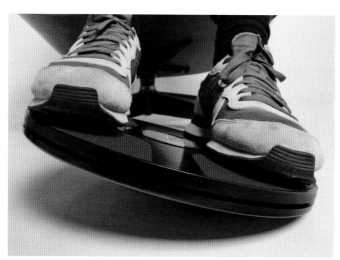

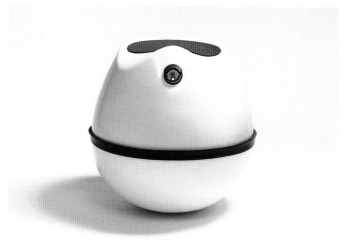

3dRUDDER

This little pad allows people to move using their feet. In titles such as *Nature Trek VR* by developer John Carline, you can push with your toes to move forward or backward, tilt to the left or right to move sideways, rotate to turn around, or press opposite heal-toe to move up and down.

VRGO CHAIR

This pod-like unit allows you to move in different directions while sitting down. Compatible with VR experiences on most platforms, the chair features an accelerometer, gyroscope, and magnetometer to move you through a virtual world.

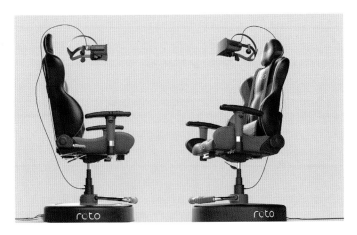

ROTO VR

This motorized swivel chair will rotate you to the direction you are looking based on your input from a controller. For example, if you press left, the chair will also turn left.

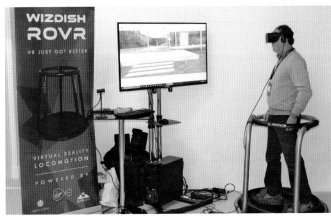

ROVR

This omni-treadmill allows a person to walk and move freely in VR. It consists of a platform that the user can stand on wearing special low friction shoes. A sensor underneath the dish picks up the vibrations, which are translated into forward motion in the direction the user is facing.

REDIRECTED WALKING

The team at the University of Tokyo has devised a clever "redirected walking technique" that utilizes physical clues that alter the sense of spatial perception of people wearing virtual reality headsets. Inside the headset, the user sees a virtual representation of a flat wall as they walk, but in reality, they are touching a full 360° convex surface wall. Combining a sense of touch with misleading visuals, the user feels like they are walking in a straight line, effectively an "endless corridor," creating the sensation of traversing large distances in small areas.

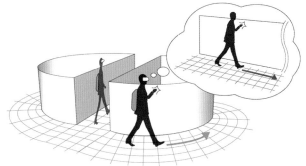

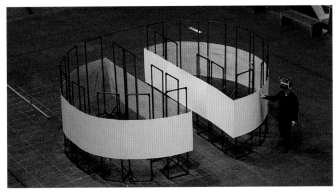

THE WORLD IN 360 DEGREES

360° VIDEO

360° cameras have been put nearly everywhere, from soaring eagles to the side of a Maxus 9 rocket traveling 2.2 miles per second (3.5km/s) into space. They give us the chance to get closer to dangerous situations, access VIP areas, or live moments different to our regular lives.

360° VIDEOS CAN be "aware of your presence," wherein actors will look at and talk to you, or you can be a voyeur in a scene playing out in front of you, as in the horror short *3am* by Dimension Gate Inc. available on YouTube (and shown at right). The entire sequence is shot CCTV-style as you witness a series of ghostly events occurring to a woman in her bedroom. Her reactions guide you to look in certain areas, and perfectly exemplifies how horror is an ideal genre for the format.

360° videos are also fantastic at telling stories about extraordinary people and nature. *USA Today*'s VRtually There app includes a narrated piece wherein you witness 15–20 million bats emerging from Bracken Cave outside San Antonio. The epic scale and majesty of so many bats flying out forces you to look up and around as you would as if you were there for real, accompanied by a guide. VRtually There also takes viewers kayaking down rapids and even up in the sky out on the edge of a skywriting plane.

Those experiences use audio narration to acknowledge your presence, but in others, the actors talk directly to you. In *The People's House* by Felix & Paul Studios, Barack Obama gives you a one-to-one tour of the White House, something you are very unlikely to experience in real life.

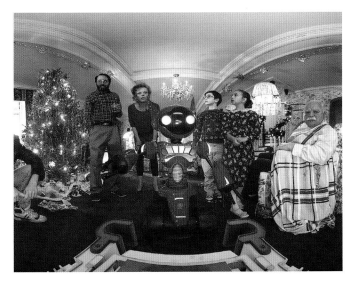

MIYUBI BY FELIX & PAUL STUDIOS

This 40-minute virtual-reality comedy is about a Japanese toy robot—inhabited by you, the viewer.

BEHIND THE SCENES

For the movie industry, 360 is a great way to market a new release. Behind-the-scenes content works exceptionally well, putting you in the shoes of a member of the crew. In Paramount's *Transformers: The Last Knight* Behind the Scenes, produced by Holor Media, you get a privileged viewpoint from the crane that films a high-speed pursuit across Tower Bridge, and witness a fireball-smattered knight-battle stunt sequence.

THE BACKYARD SCIENTIST

The YouTube sensation Kevin Kohler, aka "The Backyard Scientist," is famous for his dangerous experiments, racking up hundreds of millions of views on the video-sharing platform. He partnered with Amaze, a VR experience platform for content creators and production companies, to create a choose-your-own-adventure-style 4K stereoscopic 360° app, where you can watch several dangerous experiments. These include a speeding rocket knife, a hot ball burning through polystyrene and a liquid-nitrogen-versus-flamethrower battle.

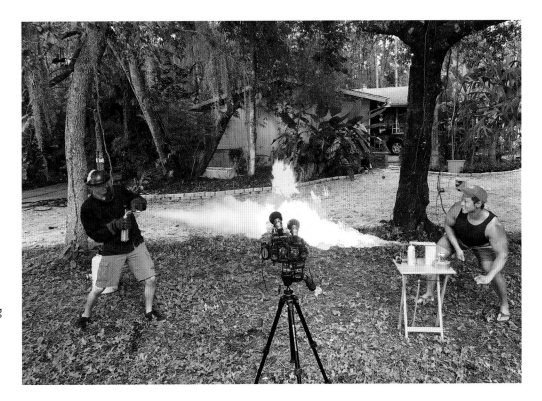

360° VIDEO FORMATS

360° images and videos require every angle of the scene to be running at the same time, so you can freely move your head and decide where you wish to look. Similar to how the panorama function works on your phone, this video is made by stitching together multiple camera angles from one fixed point of view. The footage is then projected onto a 2D video format via various types of mapping.

EQUIRECTANGULAR

This is the most common form of projection mapping—think of the standard rectangular map of the world. The technique was first invented by Greek cartographers 2000 years ago and is still the standard for world maps, but the principle is quite simple: latitude lines—e.g., the equator—become horizontal lines on the rectangle, and all longitude lines become vertical lines.

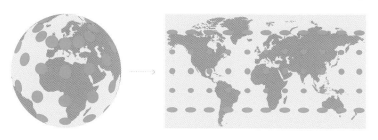

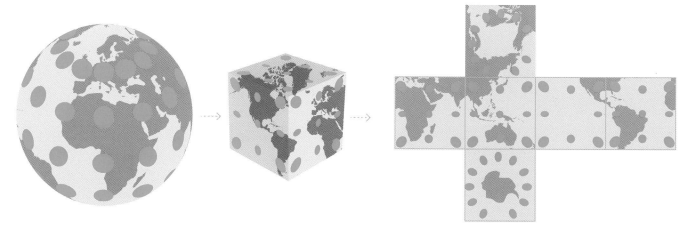

CUBE MAP PROJECTION

This is the preferred format for Facebook 360, although it has been around for years, having been used in video games since the 1980s. It does not distort the image or contain any redundant pixels while keeping an economic file size. Imagine a sphere divided into six equal parts, and then each part projected onto a face of a cube. Then each face is reassembled as a 2 x 3 grid of squares to make the overall size of the rectangle smaller.

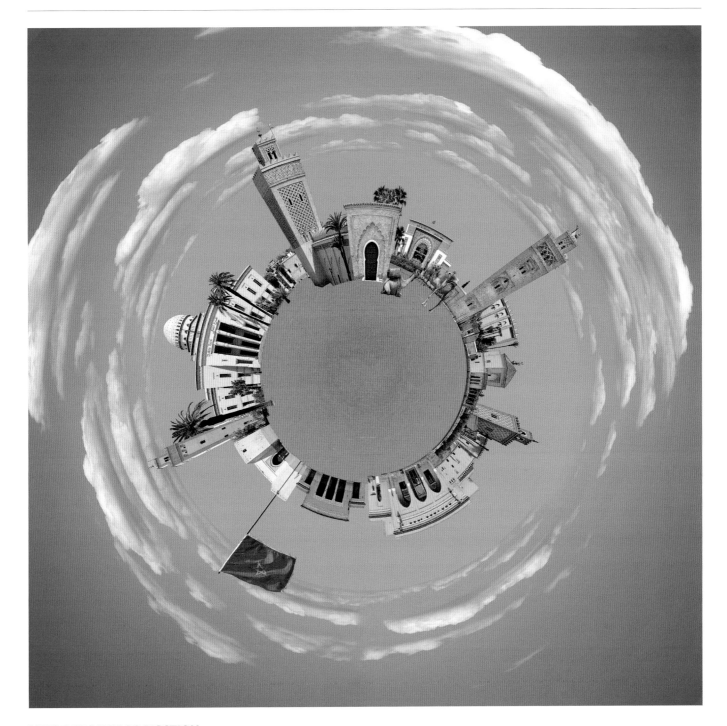

LITTLE PLANET PROJECTION

Also called stereographic projection, this is an artistic projection-mapping technique that looks like a tiny planet taken from above with a fisheye lens. They are created by stretching an entire equirectangular image around one pole. Not useful for storing 360° videos, but they look spectacular!

CONSUMER 360° CAMERAS

There is a wealth of 360° cameras falling well within the price brackets of everyday gadget lovers. They might lack the resolution, frame rate, dynamic range, and audio quality of the professional systems, but they are highly convenient to shoot and edit with. Consumer 360° cameras generally work with two 180° fisheye lenses pointing in opposite directions. Software stitches the images together and outputs a single MP4 file, which is easy to work with.

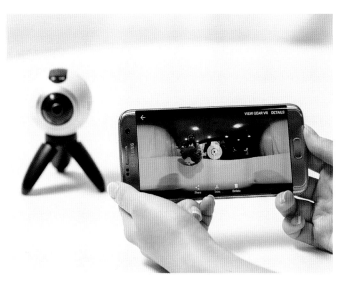

SAMSUNG GEAR 360

The Gear 360 shoots 4K and is compatible with iPhones and Samsung-only Android phones. You can wirelessly monitor the output on your phone and stream live to Facebook and YouTube. Included in the app is a 360° video-editing solution for titles, transitions, and lighting visual effects.

360FLY 4K

The 360Fly 4K is ideal for action footage such as hiking, mountain biking, skateboarding, and even diving—with it being waterproof up to 30 feet (9m). You can stream live 360° video to Facebook and YouTube, and edit your footage within the app. For extra effects and titles, you can use the free 360Fly desktop editing suite.

A great feature is its ability to save GPS and other sensor data to your videos. Using RaceRender.com software, you can overlay heads-up display graphics such as acceleration, altitude, location, and speed—ideal for POV 360° videos.

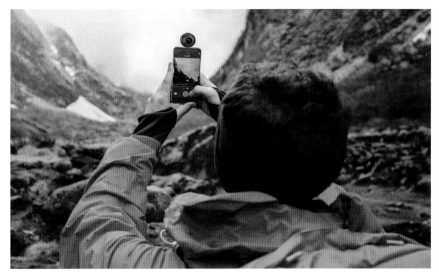
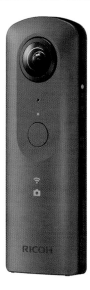

INSTA360 NANO & AIR

The Nano fits directly to the iPhone 6 and above, and the Insta360 Air connects to a range of Android phones, 5.1 or above. Praised online for their picture quality, they also feature image stabilization. The Insta360 Air serves as a 360° webcam too, ideal for Skype calls where there are several people in the same room, and the packaging for both cameras doubles as a Google Cardboard VR headset.

RICOH THETA V

Google Street View compatible, the Theta V captures 360° 4K video and immersive spatial audio. It can also live stream in 4K and be used underwater with an additional case.

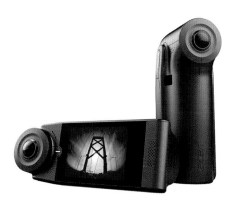
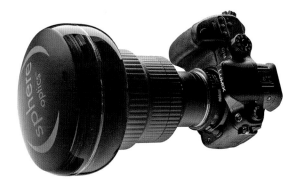

ACER HOLO360 & VISION360

The Acer Holo360 is phone-sized, features a 3-inch display, and can capture 4K 360° videos. It also runs Android 7.1, making it easy for users to share their videos over social media. The Vision360 acts as a high-end dash cam, which captures every angle of your car if you experience a collision. You can then upload that footage to the cloud with GPS and speed coordinates, which can be used in evidence.

THE SPHERE

If you own a DSLR camera, you could consider the Sphere, by Sphere Optics, which attaches to your lens to capture a full 360 x 180° view, without any stitch lines.

With Google research finding that 75% of 360° viewers only look at the front quadrant of the video, it makes sense that there are a few affordable cameras that limit the capture field to the front 180°. The benefits of this approach are reduced data sizes (important for streaming on YouTube) and a more convenient way to shoot, as you do not need to concern yourself with what can be seen behind the camera. What is most compelling, however, is that the format, called VR180 by Google, is stereoscopic, compared to the monoscopic capture of the consumer-level 360° cameras.

LUCIDCAM

This small camera works with just one button and features two wide-angle lenses that fuse together a 180° stereoscopic video. Editing can be done on regular software such as Adobe Premier Pro, and it can broadcast live 4K-per-eye video on YouTube at 30fps. When sharing to Facebook, you can select a preset background for the 180° part that is not in-shot, as well as your own logos, text, or even another video. For full 360° stereoscopic video, the company also offers a 360° rig that holds three LucidCams.

LENOVO VR180

Developed according to Google's VR180 certification, this camera is a point-and-click affair. Like the LucidCam, it features two wide-angle lenses at eye-distance apart to generate a stereoscopic image. As you can imagine, it is flawlessly compatible with Google's YouTube platform, making it easy to stream live VR180 to the world—perfect for broadcasting live immersive footage of your holiday or video messages to loved ones miles away.

If you are clever, you can shoot a background in one take and then the foreground where the action happens. In the edit, you can combine them to create a stereoscopic near-360° video. You can view sample footage of both cameras by searching Discover VR180 and LucidCam Sample Footage on YouTube.

GOING LIVE

Live 360° streaming is exciting and incredibly easy. You can broadcast full immersive video to Facebook, Periscope, and YouTube for anyone to view in a headset or using their mouse on a desktop. Most major consumer 360° cameras can stream directly from their apps. For example, on the Insta360, you just need to hit the Live button and select which social platform you wish to stream to. On the Facebook section, you can stream to public, friends, or groups.

If you own a Ricoh Theta S, you can start streaming to YouTube following these steps:

1. Download and open UVC Blender from theta360.com/uk/support/download/uvc

2. Plug in your Theta via USB, and register when prompted. Then unplug again.

3. Turn on your Theta in Live mode by pressing the Camera and Power button at the same time. Plug the Theta back into the computer.

4. Download obsproject.com/
Under Scenes, press + and name your scene. Under Sources, press + and select Video Capture Device.
Select Create New and give it a name. The Properties menu will pop up.

5. In the Properties menu, select THETA UVC Blender. Right click on the video feed, scroll down to Transform, and then select Stretch to Screen.

6. Go to Youtube.com/my_live_events. Select Create Live Event. Go to Advanced Settings and select 360° video.

7. Select Create Event and go to Ingestion Settings. Under Custom Ingestion, create and name a new stream.

8. Copy the URL under the Stream Name.

9. In OBS, go to Settings, then Stream, and choose your streaming service (in this case, we would choose YouTube). Paste the URL into the Stream Key box.

10. Finally, select Start Streaming and you will be broadcasting 360° to the world!

HIGH-END 360° CAMERAS

THE WORLD IN 360 DEGREES

The trailblazers at the height of the VR boom had to build their own Frankenstein devices, hacked together with multiple cameras facing all the directions. Today, professional filmmakers have plenty of choice of cameras when it comes to high-end 360° production, which can cost as much as a sports car.

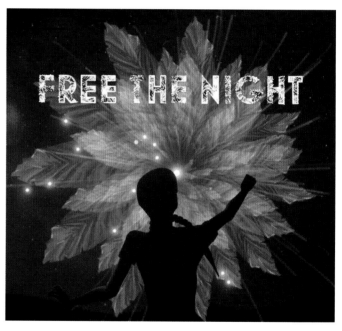

JAUNT ONE

This camera is a stereoscopic 24-camera beast that can shoot 360° at 120fps in 8K. The integrated 3D sound-field microphones capture ambisonic 360° sound that can be edited in post with the Dolby ATMOS toolset. Their Creator program invites content makers to submit their productions for their app, which is available for free on Google Play and the Apple App Store (simply search Jaunt VR). Their technology is also being used to make interactive films for mixed reality.

Produced in partnership with Microsoft, *Free the Night* is their first 6 Degrees of Freedom (6DoF) original—a journey inspired by the stars of the night sky. Throughout the film, viewers pick lights out of a city skyline and place them back into the night sky right where they belong.

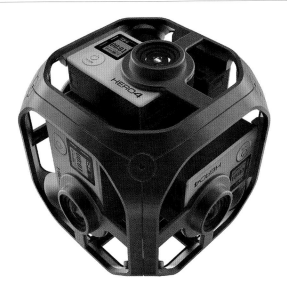

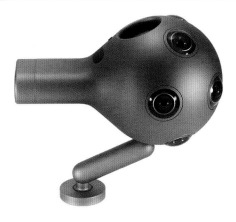

NOKIA OZO

Nokia made a surprise entry into the 360° world with a high-end camera called the OZO. Eight lenses capture a frontal stereoscopic image (monoscopic at the back), and features eight onboard microphones for headset-tracked spatial audio, based on new advanced psychoacoustic technology.

The OZO is a director's dream, as it offers the ability to monitor, on-set, a live-stitched 360° feed on an Oculus Rift or Vive. It can also broadcast live stereoscopic 360° visuals and sound, as used by Sony Pictures to broadcast live 360° video of their events.

GOPRO OMNI

The lowest priced on the list, the Omni by GoPro is a monoscopic 8K 360° setup that consists of 6 HERO4 Black cameras, the rig, and Kolor Autopano Video Pro software to stitch and process the images together. Its small size makes it popular for directors shooting in small spaces, and also for drone photography.

YI HALO

The Yi Halo packs 17 synchronized cameras into an all-in-one rig that's capable of stereoscopic immersive content in 8Kx8K resolution. The camera is based on Google Jump—Google's open-source Blueprint arrangement of cameras for 360°. Jump Assembler software takes the raw-video feeds from each of the 17 cameras, and combines computer photography with computer vision to generate thousands of artificial viewpoints between each camera for smooth 360° stereoscopic vision. The Yi Halo can be entirely controlled by an Android app.

360° AUDIO CAPTURE

02

What we hear plays a vital role in how we perceive the world. Our two ears are perfectly positioned to give us a 360° audio picture of the world around us. Our brains process the small time differences between our ears to accurately locate a sound's source, which is not only vital for our safety, but it also compensates for our relatively narrow field of view.

TO SIMULATE THE way we perceive sounds in virtual reality, a technique called "ambisonic spatial audio" is used. Stereo sound consists of fixed left and right directional sounds, whereas spatial audio alters the individual sound directions as you move your head. YouTube supports the format, which can be enjoyed with a regular pair of headphones. If you want to create videos with true spatial audio, you should consider an ambisonic microphone.

SENNHEISER AMBEO

Sennheiser's AMBEO consists of four directional microphones to capture a true ambisonic sound field, which can be recorded to any field recorder capable of handling four audio inputs. The AMBEO software plugin converts the recording from A-format to B-format—a speaker-independent representation of a sound field. This can then be handled by spatial audio software such as the free Facebook Spatial Workstation.

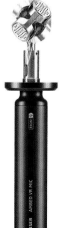
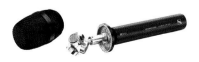

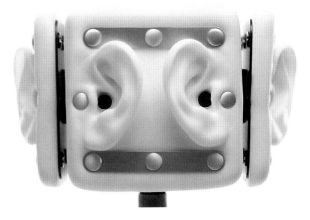

3DIO

Designed to replicate the way sound travels through the human ears, the 3Dio is an "omni binaural" microphone that consists of four pairs of "ears," each pointed 90° from the adjacent pair, producing a single-point, four-position binaural perspective of any audio environment. The audio can be synchronized to a 360° video with a downloadable volume-control script. It is a microphone that has proven highly popular with ASMR artists on YouTube.

FACEBOOK SPATIAL WORKSTATION

The Spatial Workstation is Facebook's 360° software plugin for positioning audio in space, specifically for virtual-reality videos. With it, the user can identify sound sources from any direction in 360° space, wearing just regular headphones. The producer is able to anchor multiple sounds to multiple sources in the 360° video. The 360 Audio Engine then takes care of head-tracking in real time on the playback device. You do not even need an ambisonic microphone, as the software allows you to add multiple audio sources to create an artificial ambisonic mix compatible with YouTube 360 and Facebook 360.

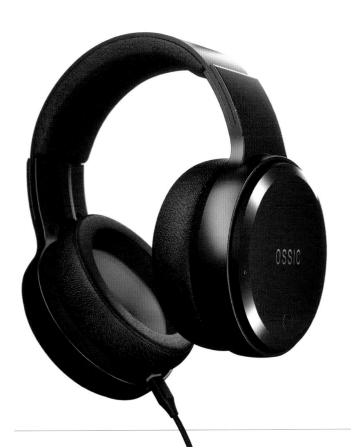

OSSIC X HEADPHONES

The OSSIC X is a pair of headphones that features head-tracking, a multiple driver array in each ear cup, and individual anatomy calibration to deliver calibrated 3D audio, achieving greater immersion, specifically for virtual- and mixed-reality applications.

FIND & WATCH 360° VIDEOS

YouTube hosts thousands of hours of 360° videos. Whether you want to scare yourself half to death with a voyeuristic horror, get a prime position in a Minecraft build challenge or ride a roller coaster in Japan, there is something for everyone.

TO GET STARTED, open the YouTube mobile app and search for the official YouTube Virtual Reality Channel. Select Playlists to find collections such as Experience Music, Thrills, and Eyewitness. Press Play on a video you would like to watch and rotate your phone to landscape mode. Tap the screen and press the goggle icon on the bottom right. The screen will split into two views meaning you can now enjoy the video in VR mode with the phone inserted into a mobile VR headset.

The videos range considerably in quality, and with so many to choose from, it can be tricky to find the gems. You can look out for the Featured and Best Of 360 curated lists on the YouTube Virtual Reality channel. 360° videos can be searched according to your tastes too. For example, if you are a horror fan, search "horror" and then tap the filter icon at the top right, choosing 360° from the options. You can even watch live 360° broadcasts by keeping an eye on the Live Playlist too. Vimeo also features a 360° section and supports up to 8K resolution. Just download the Vimeo app and search 360° content.

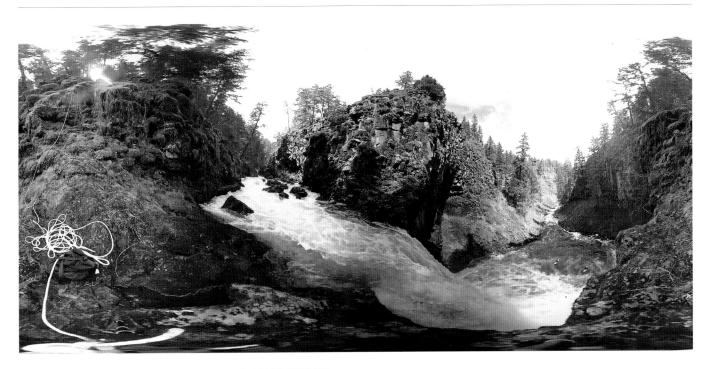

DROP FROM A 70 FOOT WATERFALL BY USA TODAY

A fascinating short that captures the fear, anticipation and danger of riding a kayak off a 70-foot waterfall. Combining drone and on-board kayak cameras with narration, this mini documentary makes you appreciate the lengths some thrill seekers will go to escape their comfort zone.

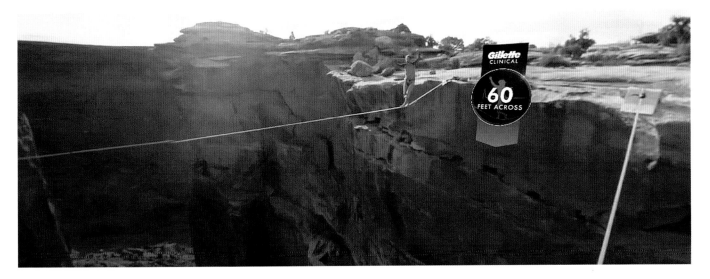

WALK THE TIGHT ROPE BY DISCOVERY VR

The stakes do not get much higher than this. Hundreds of feet above the canyon floor in the deserts of Moab, Utah, you can walk the fine line between a majestic view and a disastrous fall.

HOW TO WATCH MOVIES IN VR

THE WORLD IN 360 DEGREES

Virtual reality now allows us to recreate the cinema experience in the home but with more freedom. You can jump from seat to seat, change the size of the screen, or even tweak the decor of the auditorium. For example, Cineveo from Mind Probe Labs allows you to watch video content in a 1960s drive-in theatre, a haunted valley, and the middle of the ocean.

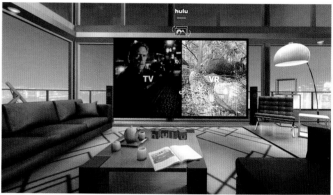

THE GIANTS OF movie streaming, Netflix and Hulu, both offer VR theater versions of their services. Netflix VR allows you to access your account in a stylish cabin, decorated with posters of classic movies, where you can view your films on a large screen. Hulu VR (US only) also offers social viewing for Gear VR and Oculus VR owners, where up to three friends can watch and chat about their Hulu movies displayed on a large screen no matter where they are in the real world.

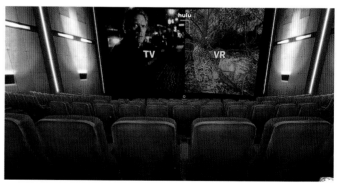

The PlayStation VR features "cinematic mode" that projects PlayStation movie rentals, 3D Blu-rays, and online content from the likes of BBC iPlayer and HBO GO on a simulated floating screen.

VR IN AMSTERDAM

The Virtual Reality Cinema in Amsterdam features two rooms full of 360° swivel chairs for up to 40 attendees who can watch 30 minutes of themed 360° content on Gear VRs.

Google Daydream owners can also watch their Google Play downloads on a virtual cinema screen. However, due to DRM, there are no official apps that support watching Google Play titles on other mobile VR headsets such as Google Cardboard. One workaround is to use the free NOMone VR browser, available on Google Play. By logging into your Google Play account within the app, selecting your movie, and then entering full-screen mode, you can watch it on a big screen in front of you, though it is not a simulated-cinema environment, nor does it support 3D.

CINEVR

Oculus have Oculus Video and HTC have Vive Video, and there are an incredible number of iPhone and Android virtual-cinema apps available such as CineVR. This free social-VR app features a highly realistic cinema environment, surround sound, and dynamic lighting effects. You can watch HD and 3D movie trailers as well as 360° clips, and stream regular YouTube videos to the large virtual screen.

WATCH YOUTUBE ON A BIG SCREEN

You can also watch any YouTube clip on a simulated VR screen. Simply find the video you wish to watch and select "View in Cardboard" in the Settings menu. American residents can access over 100 movies from the Paramount Vault channel and Viewster has plenty of classic horror movies you can relive in VR cinema mode.

SHOOTING YOUR FIRST 360° MOVIE

360° videos are everywhere, and some attract millions of views. We all have a story to tell, and with 360° cameras now affordable, you can share them with the world in a highly engaging way. 360° production offers the opportunity to break old rules and create new ones, as done to great artistic effect in ARTE's film Alteration. If there is one rule with 360° production, it would be to get out there and experiment. However, there are some simple practices to assure comfortable experiences for your audience.

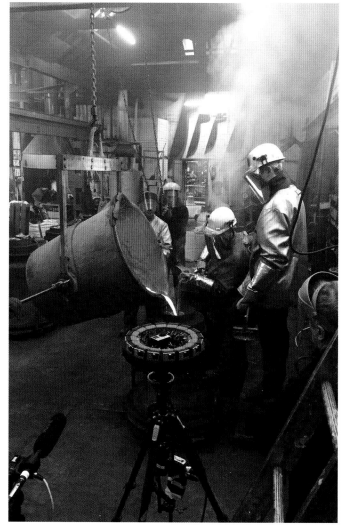

THE FINAL BELL

These behind-the-scenes shots of a Visualise VR production show the casting of the last-ever bell at Whitechapel Bell Foundry, which was, at the time, the oldest surviving manufacturing company in England. The 360° camera rig is their own custom-modified Google Jump (GoPro Odyssey).

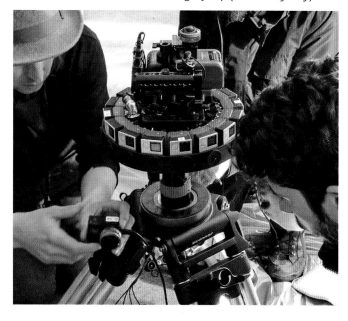

- 360° filming captures everything, so consider where you will hide the microphones, lighting, and people not acting in the scene.

- Let the scene just happen as if the actors were performing on stage. Some of the most effective 360° videos are more akin to theatre productions, with a limited range of angles.

- Camera movement can be jarring in 360°. Use a tripod with a small footprint and no arm handle such as the GRIFITI Nootle Stand so the feet are less obvious. You can still include movement in-shot as long as the frame of reference is stable, for example, by attaching the camera to a windscreen in a fast-moving car.

- The video *Get Barreled in Tahiti* with C.J. Hobgood and Samsung Gear VR 360 is full of movement, but because in most shots, the camera is attached to something stable, such as a boat or surfboard, it is not nauseating to watch.

- You have passed rotation control to the viewer, so do not rotate the camera in-shot and avoid POV walking shots.

- Consider how you will guide the viewer's gaze. If you are shooting a drama, get the actors to react to something, or for a documentary, consider audio narration (for example, "Look up and you can see the sky pool").

- Decide whether you want the viewer to be a voyeur or part of the action. If part of the action, be sure to have the actors acknowledge the viewer occasionally.

- Budget cameras normally use two fisheye lenses that capture about 180° each and merge them together,which can generate an apparent stitch line. Keep important objects out of this area by positioning them central to one of the lenses.

- Don't overuse the 360° space. Most people don't want to constantly turn their head, just as we don't in real life. Position most of your scene in the front 180° of space and only use the background occasionally. Allow the viewer to explore for a few seconds at the start before introducing the main scene elements.

- If you wish to boost lighting in a scene, consider replacing the lamp lights with more powerful fittings. LED light strips can be easily hidden too.

- Got a drone? Strap the camera to that. Consider buying a waterproof housing for dynamic underwater shots, or take advantage of the camera's time lapse feature for awe-inspiring sunsets.

EDITING YOUR FIRST 360° MOVIE

02

THE WORLD IN 360 DEGREES

There are multiple low-cost editing packages that support 360° editing, one being Movie Edit Pro Plus by Magix, which we will be using to edit our first 360° video. For this guide, I shot some footage using a Ricoh Theta S at the former London Olympic site, with the intention to make a longer documentary to show how the area has changed since 2012. However, this guide is applicable for most consumer cameras.

TRANSFER & CONVERSION

Transfer your video files to a folder on your computer via a USB lead. Before editing, you will need to convert the video files to an equirectangular format if not already. Download the Ricoh Spherical Viewer from:

https://theta360.com/uk/support/download/.

Open the Spherical Viewer and convert each video you wish to edit, ensuring top/bottom is selected.

Open Magix Movie Edit Pro Plus and create and name a new project.

In Movie Settings, select one of the 360° options according to the native frame rate and resolution of your camera.

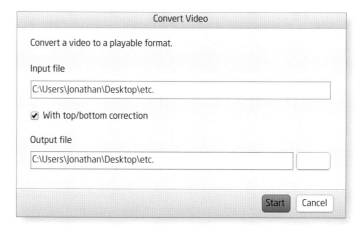

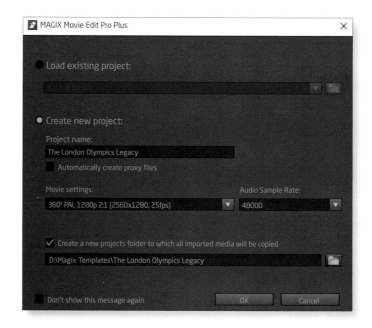

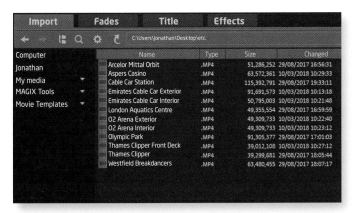

Go to the Import tab, select all your clips and then import them. They will now appear on your timeline. To check that you have imported your 360° video files correctly, select the drop-down menu underneath the MAGIX logo on the top left and click 360° video. Using your mouse, you should now be able to move the video in all directions. For editing, it is best to work in regular Standard (2D) mode from the same drop-down menu. You can trim your clips by moving the orange pointer to the parts of the clip you wish to cut and selecting the scissors to trim.

I shot this video on a very overcast day, so I tweaked the brightness and contrast via Effects > Video Presets. I also improved the color saturation by increasing the HDR Gamma as well as creatively increasing the speed of the cable cars. In the Video Presets you can be as creative as you like.

Get the core of your edit together as you would a 2D video. Fade transitions work well in 360°. To do this, go to Fades and drag your fade to overlay the two clips you wish to fade between. For 360°, I suggest Standard > Flexible Crossfade.

Let's now add some titles, starting with an opening. In this simple case, we will add an animated title against a black background. Go to Titles > Templates, Intro/Outro followed by your title template. Select it and press the down (download) arrow button. This will add the title template to your timeline and open up the title editing tool (shown left). Type in your title, adjusting size, color, etc. and then drag the title box to the beginning of the timeline.

Magix Movie Edit Pro Plus automatically distorts the video to 360° playback. Once you are happy with your title, select View 360° from the top-left drop-down menu to see how it looks. You will notice that the title is automatically distorted around a sphere.

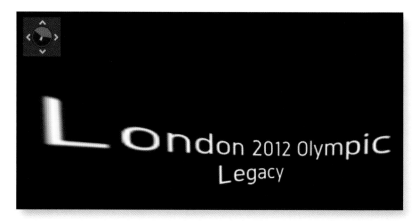

We can now add some annotations to various parts of the video in a similar way. On the timeline, select the video clip you wish to add an annotation to (it should turn yellow). Click the Title Tab and enter your title in the title box.

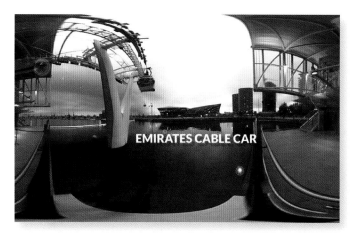

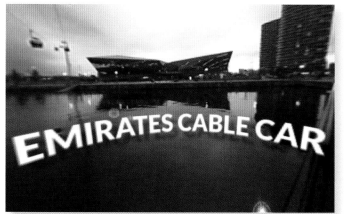

Using your mouse, position the annotation where you would like it to be anchored. It will look strange in 2D mode but switching to 360° View will show you how it will appear on YouTube 360. Here, I have positioned an annotation to name the cable car.

A really nice feature to have on 360° videos is 2D planes embedded on the sphere. In this demo clip, we will add a picture of how the Aquatics Centre looked in 2012.

Download the images you wish to use for your planes to your project timeline in the same way as your videos. Drag the picture onto your timeline so it is underneath the scene you wish to add it to and switch to 360° view. With the picture still highlighted go to Effects > View > Animation > 360° Editing. Activate 360° Editing, and select Position Object in 360 Space. In the alignment section, you can now move the 2D image to where you want it to appear in the 360° video, all in 360° space. Work in View 360° mode as you adjust its position. You can adjust the size of the 2D image with the perspective slider.

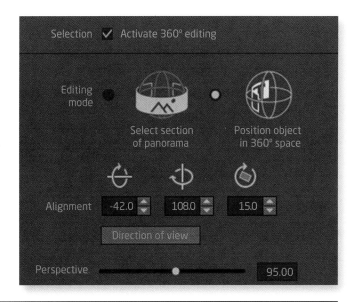

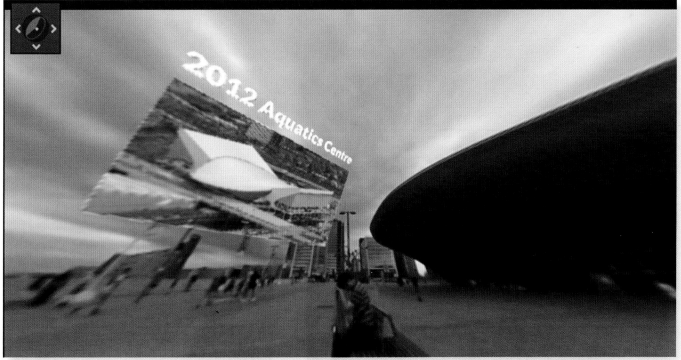

Next, we will add a label to the image, but this time we will edit in 360° mode. Click on the video clip on the timeline, select Title and add your text. It is important to keep the text to just a few words. Click on the title box on the timeline (so it turns yellow) and then Effects > View > Animation > 360° Editing. Activate 360° Editing with Position in 360 Space

selected. Like the 2D image, you can now adjust the title with the Alignment Options so it is positioned near your image. To export your 360° video to YouTube, go to File > Export Movie and export as a MP4. The software will automatically convert it to 360° mode and you can upload to YouTube the same way as a regular video.

GOOGLE STREET VIEW

02

THE WORLD IN 360 DEGREES

Since 2007, Google have been ambitiously capturing 360° images of the world's streets and landmarks, which can now be viewed in virtual reality at the click of the goggles icon on the Google Street View app.

EXPLORE

Download the Google Street View app from the Apple App store or Google Play and get started with the Featured tab. Zoom into an area you wish to explore on the map, and the app will serve up "Featured Collections" such as *Inside the Rijksmuseum* in Amsterdam, *Catalonia Highlights*, and *Natural Resources of Wales*. Clicking on a collection will open up several mini tours that can be viewed wearing your mobile VR headset.

CONTRIBUTE

You can also contribute your own content via the Google Street View app, and you do not even need a 360° camera. Logged into your Google account, go to Profile, select the camera icon, and choose Using Your Camera phone. Hold your phone up and scan each environment, guided by the orange dot, until you have scanned a complete 360° picture (this will be indicated by a green tick). The app will then stitch those images together and make them spherical. You can preview your creation in the Private tab. Geotagging will automatically locate where the image was taken, and you can then publish this to Google Maps for others to see.

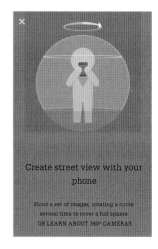

Create street view with your phone

Shoot a set of images, rotating a circle several time to cover a full sphere
OR LEARN ABOUT 360° CAMERAS

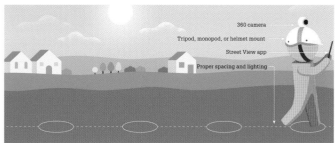

360 camera
Tripod, monopod, or helmet mount
Street View app
Proper spacing and lighting

Google Street View
☑ trusted

Businesses can benefit from having virtual tours of their premises available via Search and Google Maps, and if you own a "Street View Approved" 360° camera, you can earn money by becoming "Street View Trusted Photographer." You need to have published at least 50 photospheres that adhere to Google's professional-quality guidelines before you

can be invited. In the Settings, turn on Available for Hire and check Get Listed as trusted professional for hire. Tap Join Local Guides to be eligible for an invitation. You can receive leads from Google's approved photographers, so you do not even need to advertise.

As an approved photographer, you will need to invest in an auto-stitching camera such as the 360Fly, Giroptic, or KenXen. These capture the whole sphere in one go. To produce a tour of a building, you take each sphere within two small steps of each other and the app will then auto-connect them.

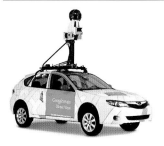

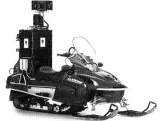

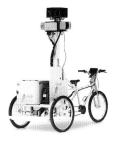

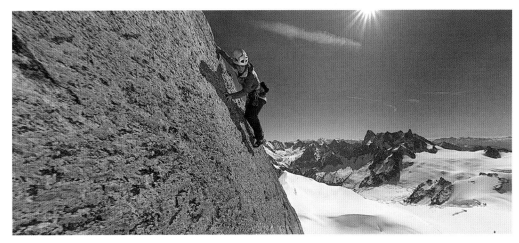

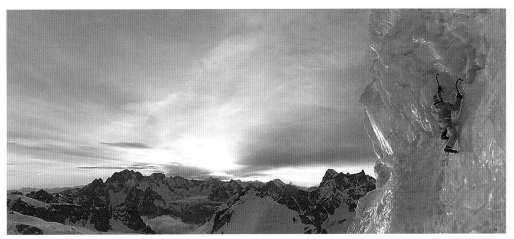

THE GOOGLE STREET VIEW FLEET

To capture the world from every angle, Google has a fleet of Street View cameras suitable for every condition.

EXPLORATIONS

From a cliff-hanging tour of Europe's highest mountain to an in-your-face dive into exotic depths, Google lets you explore the far reaches of the world.

HOW TO CREATE A VR TOUR

02

Using your phone and free software, you can create a virtual-reality tour, accessible to a worldwide audience.

THE SHOOT

To take the 360° images, we will use the Google Street View app discussed on the previous pages. Before shooting each 360° image, use your phone's voice recorder to record some ambient audio that you can add later. In my example, one of the shots features flowing water that I recorded to add contextual audio backdrop during editing.

Selecting Camera on the Street View app, take your 360° images, being sure to include the area where you will put your portals—that is, where the viewer looks in order to move to the next scene.

STREET VIEW CAMERA
Once all images have been taken, a green tick will appear.

CREATING THE TOUR

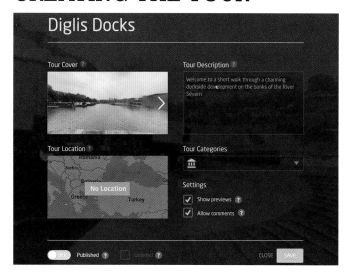

STEP 1
Open an account with https://roundme.com/ on your desktop. Transfer your 360° images from your Panorama folder on your phone to a folder on your computer, along with your ambient sound files. Create a Tour Name and upload your images in the order you wish them to be navigated.

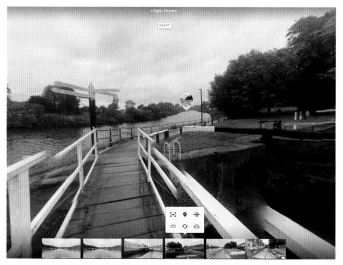

STEP 2
To place your portals, drag the image from the bottom of the screen in Edit Mode.

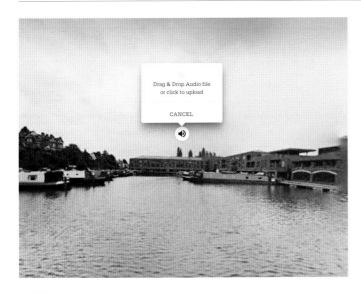

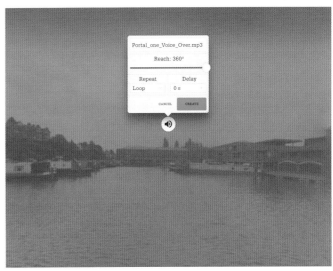

STEP 3

Once you are happy with the navigation, you can add audio, which can really bring your tour to life. This might be sound effects, overall audio ambience, or a voice-over. Roundme offers directional audio too, so you can precisely attach sound effects to objects in the scene, and even determine how widely that sound is heard. As the viewer moves their head, the sound will move as it would in real life. You can also upload multiple sound spots to the same 360 image.

STEP 4

If you wish your audio to be heard no matter where the viewer is looking, increase the Reach 360° level. If you wish the sound to be very localized to a specific object, reduce the level. If you intend to guide the viewer with a voice-over, you can use your computer's onboard microphone to record directly to the open-source sound-editing software Audacity, wherein you can also add your ambient sounds and mix them down into a single file which can be uploaded to the Roundme audio spots.

STEP 5

If desired, add a location to your first image.

Then, go to Edit Settings to complete a description of the tour, and save.

Next, download the Roundme app for either iPhone or Android and login to your account. You will find your tour under the Draft section. Here, you can test how it looks in VR mode by pressing the goggle icon. If you are happy, you can publish on the desktop, and your tour will now be available to the world!

GOPRO

If you wish to take this to a more professional level, where you can create tours for others, open a professional account with Roundme. This entitles you to a larger range of images and higher-quality uploads.

To improve the audio quality, you can invest in an external microphone for your phone, and a dedicated 360° camera will allow you to take people shots and improve general quality.

UP CLOSE WITH DAVID HAMLIN

David Hamlin is a multiple Emmy Award-winning filmmaker, having spent 17 years at *National Geographic*, focusing on bringing wildlife, adventure, conversation, and science to life. Working with *National Geographic*, Here Be Dragons, Annapurna Pictures, and Oscar-winning director Kathryn Bigelow, his first virtual reality project was *The Protectors*, a stereoscopic 360° short film that exposed the dangerous and grueling reality faced by rangers protecting African elephants from ivory poachers.

SOON AFTER, USA TODAY approached Hamlin to executive produce VRtually There (see page 42). With 75 360° shorts produced in just eight months, including live 360° coverage of the 2016 presidential election, Hamlin believes compelling VR content starts with the story:

"I have tried to bring in my experience as a television-series producer, because in many ways the workflow is the same. Ultimately you still need to take a very rigorous approach to storytelling, choosing a good story that is exploiting the opportunity that VR offers. You need to ask yourself why does this need to be a VR story and not a regular 2D story? Do we have a charismatic protagonist? Do we have clear obstacles? Do we have a chance of resolution? Get a complete story and you are off and running."

high-risk adventure, and especially privileged VIP access where you take someone where they would never normally get to go. People really flock to that."

Hamlin and his crew use various technologies. For challenging environments, he prefers to use GoPro rigs consisting of two to six cameras, depending on the situation. With so many productions under his belt, Hamlin is learning what people like and what their viewing habits are, even though many viewers of the VRtually There app do not even own headsets:

So, what advice would Hamlin give to a budding VR documentary filmmaker?

"Whether you are shooting on a $300 Ricoh Theta or a $40,000 Nokia OZO, remember the end goal: All you are trying to do is capture little treasures that you will use in the edit room to ultimately create a compelling story."

"A lot of people are watching us in Magic Window mode, and for season two, the viewing figures and time spent watching quadrupled. People love

To watch Hamlin's work, visit www.youtube.com/vrtuallythere or download the USA Today app.

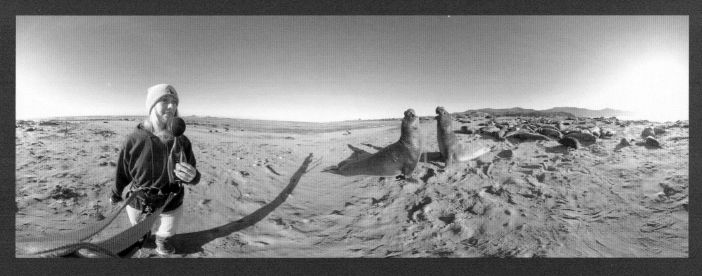

CHAPTER 03
CREATING VIRTUAL REALITY

CREATING VIRTUAL REALITY

HOW TO ANIMATE VR

If, like me, you have never animated anything in your life, would not know where to begin, or consider yourself too bad a drawer to even try, you might be surprised what you can do in virtual reality. AnimVR is a VR toolset that enables users to draw and animate in VR, using traditional animation concepts such as frames, onion skinning, and multiple timelines.

IT IS BEING used by animation professionals, but don't worry if those terms don't mean anything to you; there's a step-by-step video guide on how to create an animation of a character diving into a pool in less than 30 minutes, without any drawing experience.

You'll need an Oculus Rift or Vive for this guide, which was developed by experienced 3D Animation Director of TinyCo Games Joe Daniels. His work includes directing the animation of Marvel's *Avengers Academy* app, and he has taught Animation and Visual Effects for more than six years at Expression College in Emeryville.

He is a big evangelist for using virtual reality in his workflow, saying, "Virtual reality has recently become the fastest and most intuitive way for artists to work collaboratively in three dimensions. Previews on complex film sequences can be created without first needing to painstakingly model and rig characters and props, or employ simulation for stand-in effects like explosions without messing in anything too technical. For a shot I did a few weeks ago, I drew a character, flew it around, and then gave that to the animators, showing them the feeling I wanted them to replicate. It took 30 seconds. If I were to block this for them in traditional animation, it would have taken half an hour."

TO VIEW THE VIDEO TUTORIAL

This video guide will show you how to create a simple animation of a high diver, using a scene you can "trace" over.

1. Search and install AnimVR for Oculus Rift or HTC Vive.

2. Start AnimVR.

3. On the first screen, you will find a Featured Stages and Tutorial Menu. In the Featured Stages menu, load the HighDive04.stage file.

4. In the Tutorial Menu, select Joe Daniels. The video will load, and you can edit your scene as the video plays.

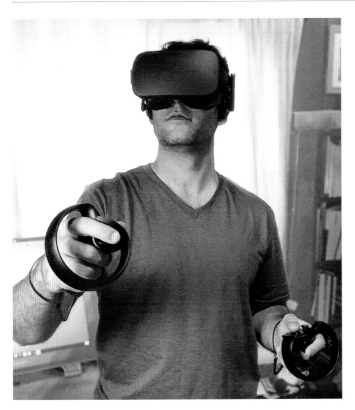

JOE AT WORK

Using a variety of creative apps—AnimVR, Oculus Quill, and Oculus Medium, to name a few—Joe can make quick sketches and cute cartoons, build architecturally improbable worlds, and even work with light and contouring to create "illustrations in the round," wherein drawing and sculpture combine in a virtual space.

STEP INTO YOUR ART WITH TILT BRUSH

03

CREATING VIRTUAL REALITY

Imagine drawing a picture and then literally stepping into it. Virtual reality is making that possible; in fact, it represents a whole new paradigm for artistry. Google's Tilt Brush is an amazing app that provides a vast range of artist's tools and a 3D canvas in which you can walk around in any direction. You can even collaborate with others in real time, creating joint masterpieces.

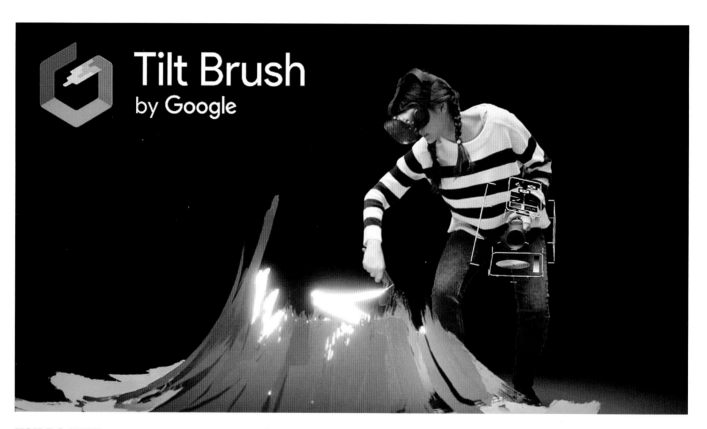

YOU DO NEED to possess some creative flair to produce pictures what would take pride of place in the Tilt Brush Gallery, but building your own world around you is so magical it is likely to inspire you to further develop your skills.

At your disposal is a feature-rich palette of colors, brush types, and animation effects. In addition to more traditional brushes such as oil, there are dynamic ones too, which you can use to paint flickering fire, falling snow, flashing neon lights, and glowing lines, plus many others. The Waveform brush is even audio reactive. Painting textures with this will leave pulsating waveforms synced to the music you select from your Music Folder.

Tilt Brush is pretty self-explanatory and can be mastered through experimentation, but here are some top tricks to get you creating your masterpieces faster.

RECREATING THE BURNING MAN FESTIVAL
VRtist Shaung Chen of Shu4n6.com used Tilt Brush to produce a 3D map of the legendary Burning Man Festival. You can view for yourself by visiting vr.google.com/sketches/dpMO_rMti6z.

TILT BRUSH TIPS

- No need to start from scratch: If you have an idea of the scene you would like to create, you can save time by importing free pre-modeled objects from third-party websites such as free3d.com, Turbosquid.com, and yobi3d.com, which offer hundreds of free assets, from spaceships to people.

- Tilt Brush can only import .OBJ files, so when searching, filter by that file type.

- To import your models, save them to Documents > Tilt Brush > Media Library > Objects. When you open Tilt Brush, you will find your models in the Library. The imports won't bring in textures and colors; however, you can use these models as templates to paint over and add your own style and colors.

- Picture tracing: If you struggle to draw, then you can import reference images from Google Images and use those to trace over.

- Save your pictures to Documents > Tilt Brush > Media Library > Images.

- Be guided: A highly useful tool is the "Guides." These are basic 3D shapes that you can "snap" your brush strokes to, as if you were painting on a hard surface. This is useful for creating neat, defined shapes.

- Use Mirror Mode: This is a great time-saving tool that reflects what you are drawing—ideal if you are drawing a symmetrical object like a car or sofa.

- You can share by taking 2D snapshots or selecting Export to Gif.

SOCIAL VR

Virtual reality can sometimes appear to be a quite isolating experience, but it need not be. Afeter all, Facebook bought Oculus for $2.2 billion, pinning their hopes on virtual reality being the ultimate platform for people to meet, engage, and interact with each other. You can already watch videos in virtual cinemas, play games, hang out in exotic locations, and create works of art with your friends no matter where they are in the world, and possibly make new some ones along the way.

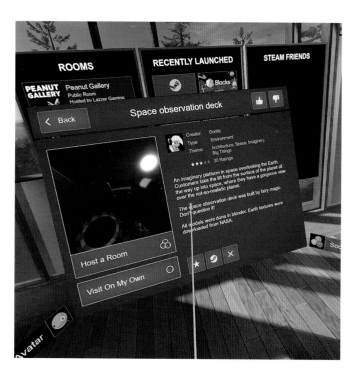

STEAMVR

Vive owners can access social-VR experiences right from SteamVR Home—the customizable launch destination. From here, you can host "rooms," inviting friends to join you to chat and play games in your home space or other environments created by the community.

OCULUS ROOMS

Available for Gear VR and Rift, Oculus Rooms have the advantage of being linked to your Facebook. Here, you can invite friends to a "party," where you choose your own ambient music, decorate the apartment with pictures from Facebook, and, once you have invited up to three guests, watch YouTube clips together, play matching- or guessing-games, or even launch a third-party multiplayer VR game.

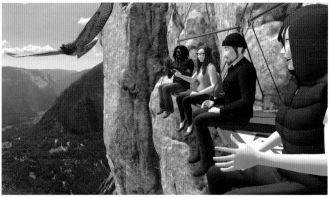

FACEBOOK SPACES

Not to be confused with Oculus Rooms, Facebook Spaces uses your Facebook profile to generate a cartoony avatar, which is animated by your mouth movements picked up by your microphone.

You can share a "space" with up to three other friends and surround yourselves with 360° photos and videos. You also have the option of using a marker to draw doodles and play games together.

Spaces is linked to Messenger, meaning you can initiate video calls in VR. Your recipient does not need a headset, as their video-chat screen will show up in a little floating square.

vTIME

One of the most impressive and accessible third-party social-VR apps is vTime. This free app allows you to match your appearance with an avatar-customization tool that boasts over two octodecillion combinations. You can join random groups or share space with friends, conversing vocally via your microphone.

What makes vTime stand out is its 20 different destinations. Rather than a random sprawl of space, vTime features ultra-realistic themed spaces, such as an underwater lagoon, an expensive private jet, or a beautiful Japanese-themed garden. You are even able to bring in the real world, by sharing your pictures and videos on a virtual screen in a boardroom, or, if you have a 360° camera, surround your friends with your immersive images—the ultimate way to share your holiday snaps.

PLAYING GAMES WITH OTHERS

Virtual-reality multiplayer games can either be online or local. Local games are similar to board games wherein you play with your friends in the same physical room.

BLOODY ZOMBIES

A great example is Bloody Zombies by nDreams—a co-op brawler playable between four people with any combination of VR-headset wearers and TV players. Working as a team as rough-and-tough cockney misfits, the player(s) wearing the VR headset(s)—signified by their character wearing a headset in the game—can support the other regular players with enhanced viewpoints, providing tactical support and guidance to in-game secrets.

KEEP TALKING NOBODY EXPLODES

By Steel Crate Games, this is another game that solves the issue of VR being antisocial if there is only one headset in the house. This party game sees the VR-wearer faced with a ticking time bomb. It is up to his friends around him (in the real world), who cannot see the bomb, to ask questions and guide him through the deactivation process, using an included paper manual containing cryptic clues.

WANDS

This highly acclaimed game by Cortopia puts you in the role of a mysterious Wielder in an alternate 1880s London. Equipped with wands and a wide variety of spells, you can battle other Wielders for fame, power, and glory. The developers occasionally host special events which attract thousands of players playing separate duels as they compete for the top space on the Leaderboard. For those without headsets, there is an online spectator mode.

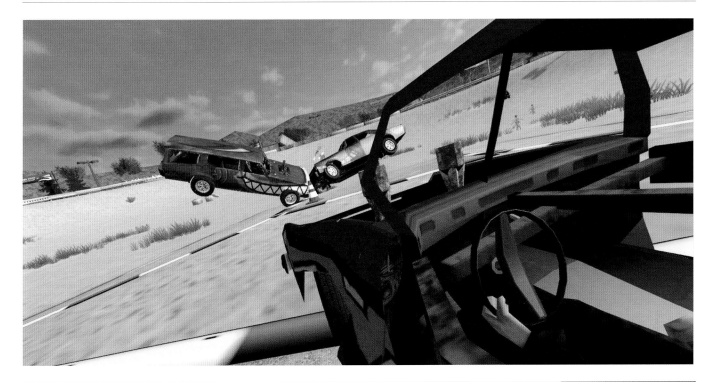

DEMOLITION DERBY VR RACING

By Destruction Crew, this is free on the Google Play and Apple App Store, and is a fun demolition car game, wherein you gain points up the leaderboard by smashing into cars controlled by players from all over the globe.

VR WEIRD BALL SOCCER ONLINE

By Tom Wierc, this is a simple but addictive football game in which you aim to shoot the ball at the back of the net against one or more players in five-minute matches.

REC ROOM

By Against Gravity, this is a virtual-reality social club where you play active games with friends from all around the world.

SURFING THE WEB IN VR

Imagine browsing a holiday website and previewing a 360° diving excursion, taking a virtual test drive through a car website, or dragging out an item of furniture from an e-commerce website and placing it in your room using mixed reality. The protocols of WebAR and WebVR are making this possible, enabling experiences to be run entirely in a browser, viewable on a phone using Chrome or Firefox.

IF YOU ARE viewing a WebVR site on a desktop and own an HTC Vive or Oculus Rift, a WebVR-compatible browser such as Chromium or Mozilla's Firefox Nightly will automatically detect your headset and display an "Enter in VR" option. A good example of this is the Tilt Brush clone A-Painter, which takes full advantage of the Vive's motion controllers.

IMMERSIVE EXPERIENCES POWERED JUST BY HTML

The beauty of WebVR is that experiences can be created by HTML—the same markup language that powers billions of websites. So for a HTML developer, it's easy to get started by learning the new markup tags. Even if you are not a developer, Mozilla's A-Frame (above), built on top of another powerful library, Three.js, makes it easy to create experiences using a visual editor (aframe.io/).

WEBAR AND WEBVR EXPERIMENTS TO TRY ON YOUR PHONE

For mixed and augmented reality, there is WebAR. Just imagine visiting a clothing e-commerce website and then entering AR mode. From there, you can stand next to a virtual wardrobe of clothes to judge whether they suit you before purchasing. Web-powered AR and VR can power the concept of the metaverse, a place of interconnected worlds, wherein Janus VR hopes to lead. Janus VR converts the web into a series of portals, letting you jump from place to place. Websites such as Vimeo, YouTube, and Instagram have been repurposed, VR-style, and you can surf the web with others in "Party Mode."

Interactive Arts, the innovation team at Nexus Studios, have a series of Web-based AR experiments that you can try on your phone, using printable markers which are tracked by your phone's camera.

→ WEATHAR

→ ARTE

WeathAR

In WeathAR, the project will retrieve your location and render in real time your actual weather as a floating 3D representation. The assets were designed and built in virtual reality using Google's Tilt Brush (see pages 74–75). Marker and app available at nexusinteractivearts.com/webar/weathAR/.

ARTE

Another experiment, ARTE, uses two markers to augment 3D scenes of sculptures taken from the Louvre Museum in Paris. Marker and app available at nexusinteractivearts.com/webar/ARte/.

KONTERBALL.COM
A neat two-player ping-pong-style game.

INSPIRIT.UNBORING.NET
A simple part-story, part-puzzle game that gets increasingly illuminated by expressing human connections. Created by Arturo Paracuellos.

CREATE A WEBVR APP IN 30 MINUTES

"WebVR brings an opportunity for web developers to dive into the world of VR without previous 3D-modeling or game-development knowledge."

—14islands

14ISLANDS IS A Stockholm-based creative-development studio that has been exploring VR and its possibilities on the web using tools such as A-Frame and Google Blocks. In this tutorial, 14islands will show you how to make a basic tropical-island WebVR scene. Here is a URL for what we will create (view on your phone):

https://14islands-webvr-tutorial.glitch.me/.

TECHNOLOGY

To build our project we'll use A-Frame, an open-source framework for creating WebVR experiences. No WebGL knowledge is required, as the content is created with HTML. The underlying work of setting up a renderer, looping an animation, and adding the controls all come with a single <a-scene> tag.

The island model used in the tutorial was made with Google Blocks, our favorite tool for creating 3D models. If you don't have access to a HTC Vive or Oculus Rift, the Google Blocks Gallery and Sketchfab are great places to find free models.

```html
14islands-tutorial ⌄    Show Live

Share ◀        1   <!DOCTYPE html>
               2 ⌄ <html>
Logs           3 ⌄   <head>
               4 ⌄     <title>Hello, WebVR! – A-Frame</title>
               5       <meta name="description" content="Hello, WebVR! – A-Frame">
+New File      6 ⌄     <script src="https://aframe.io/releases/0.7.0/aframe.min.js"></script>
               7     </head>
assets         8 ⌄   <body>
.env           9 ⌄     <a-scene>
LICENSE.md    10 ⌄       <a-box position="-1 0.5 -3" rotation="0 45 0" color="#4CC3D9" shadow></a-box>
README.md     11 ⌄       <a-sphere position="0 1.25 -5" radius="1.25" color="#EF2D5E" shadow></a-sphere>
index.html ⌄  12 ⌄       <a-cylinder position="1 0.75 -3" radius="0.5" height="1.5" color="#FFC65D" shadow></a-cylinder>
              13 ⌄       <a-plane position="0 0 -4" rotation="-90 0 0" width="4" height="4" color="#7BC8A4" shadow></a-plane>
              14 ⌄       <a-sky color="#ECECEC"></a-sky>
              15       </a-scene>
              16     </body>
              17   </html>
```

STEP 1

We'll create our scene in Glitch, an online code community, which deploys and hosts apps instantly. Sign into Glitch at glitch.com using Facebook. Go to glitch.com/~aframe, select "Remix your own" and then index.html. Your screen should look like the one above. What you are seeing is the code for a basic template with several "primitives," like a box and sphere (shown opposite), ready to be viewed on all web-enabled VR headsets. We'll use this to build upon and create our scene.

```html
14islands-tutorial ⌄    Show Live

Share ◀        1   <!DOCTYPE html>
               2 ⌄ <html>
Logs           3 ⌄   <head>
               4 ⌄     <title>14islands webvr tutorial</title>
               5       <meta charset="utf-8">
+New File      6       <meta http-equiv="X-UA-Compatible" content="IE=edge">
               7       <meta name="viewport" content="width=device-width, inital-scale=1">
assets         8       <link rel="stylesheet" hreft="/styles.css">
.env           9
LICENSE.md    10 ⌄     <script src="https://aframe.io/releases/0.7.0/aframe.min.js"></script>
README.md     11 ⌄     <script src="//cdn.rawgit.com/donmccurdy/aframe-extras/v3.8.3/dist/aframe-extras.min.js"></script>
index.html ⌄  12 ⌄     <script src="https://cdn.rawgit.com/zcanter/aframe-gradient-sky/master/dist/gradientsky.min.js"></script>
              13
              14     </head>
              15 ⌄   <body>
```

STEP 2

First, we'll add some scripts and some other data. The <script> tags must always be placed in the <head> to make sure the components we add later are registered before they're called from the scene. Add the data above in between the <head> tags.

CREATE A WEBVR APP IN 30 MINUTES

03

CREATING VIRTUAL REALITY

```html
1    <!DOCTYPE html>
2    <html>
3      <head>
4        <title>14islands webvr tutorial</title>
5        <meta charset="utf-8">
6        <meta http-equiv="X-UA-Compatible" content="IE=edge">
7        <meta name="viewport" content="width=device-width, inital-scale=1">
8        <link rel="stylesheet" hreft="/styles.css">
9
10       <script src="https://aframe.io/releases/0.7.0/aframe.min.js"></script>
11       <script src="//cdn.rawgit.com/donmccurdy/aframe-extras/v3.8.3/dist/aframe-extras.min.js"></script>
12       <script src="https://cdn.rawgit.com/zcanter/aframe-gradient-sky/master/dist/gradientsky.min.js"></script>
13
14     </head>
15     <body>
16
17       <a-scene fog="color: #c4e3ed; near: 1; far: 65">
18
19         <a-entity id="sun" geometry="primitive: sphere; radius: 10" material="color: #FfeeCC; shader: flat"
20         light="color:#ffffff; intensity:0.3 type: directional; castShadow:true; shadowCameraVisible: false; shadowCameraNear: 45;
21         shadowCameraFar:100; shadowCameraLeft:-10; shadowCameraRight:10" position="-8 12 -60"></a-entity>
22         <a-entity light="type: point; color: #ffffff; intensity: 0.2;" position="0 -2 0"></a-entity>
23         <a-entity light="type: ambient; color: #ffffff; intensity: 0.7;"></a-entity>
24
25         <a-gradient-sky material="topColor: 137 194 214; bottomColor: 196 227 237;"></a-gradient-sky>
26         <a-entity id="ocean" ocean="density: 140; depth: 140; speed: 1" material="color: #185b75;
27         opacity: 1; roughness: 1;" rotation="-90 0 0" position="0 -0.6 0" shadow="receive: true; cast: false;"></a-entity>
28
29         <a-entity obj-model="obj: #island-obj; mtl: #island-mtl" position="1 5 -2.5" scale="15 15 15" rotation="0 -105 0" shadow="cast:true"></a-entity>
30
31       </a-scene>
32     </body>
33   </html>
```

STEP 3

Now let's remove the default geometries and start personalizing by adding sky, ocean, and lights.

<a-gradient-sky> and <a-entity ocean> are components built by A-Frame users, found at github.com/aframevr/awesome-aframe. This is a collection of open-source resources created by the A-Frame community, free to use by anyone. The scripts we added earlier to the <head> tag will enable them to work. In the <body>, add the entities and scene above, which you can copy from this.

Both components are customizable. You can play around with the water's density, speed, and depth by tweaking the properties. The sky's top and bottom colors need to be specified as RGB values.

All the tags we are including in the scene are called "entities." Entities are placeholder objects to which we plug in components to provide them appearance, behavior, and functionality.

The sun is made of an entity with geometry and material components attached to it, so that the scene will render a bright sphere. To position the sun in the distance and make it cast light onto the ocean, we attach position and light components as well. By configuring the light's properties, we can simulate real-time shadows in our scene, which will be visible as soon as we load the model.

```
1   <!DOCTYPE html>
2 ▾ <html>
3 ▾   <head>
4 ▾     <title>14islands webvr tutorial</title>
5       <meta charset="utf-8">
6       <meta http-equiv="X-UA-Compatible" content="IE=edge">
7       <meta name="viewport" content="width=device-width, inital-scale=1">
8       <link rel="stylesheet" hreft="/styles.css">
9
10 ▾    <script src="https://aframe.io/releases/0.7.0/aframe.min.js"></script>
11 ▾    <script src="//cdn.rawgit.com/donmccurdy/aframe-extras/v3.8.3/dist/aframe-extras.min.js"></script>
12 ▾    <script src="https://cdn.rawgit.com/zcanter/aframe-gradient-sky/master/dist/gradientsky.min.js"></script>
13
14     </head>
15 ▾   <body>
16
17 ▾     <a-scene fog="color: #c4e3ed; near: 1; far: 65">
18
19 ▾       <a-assets>
20 ▾         <a-asset-item id="island-obj" src="https://cdn.glitch.com/5052471b-57bb-4fd2-a6ac-d7808c42910b%2Fisland5.obj?1504879913213"></a-asset-item>
21 ▾         <a-asset-item id="island-mtl" src="https://cdn.glitch.com/5052471b-57bb-4fd2-a6ac-d7808c42910b%2Fisland5.mtl?1504880072617"></a-asset-item>
22       </a-assets>
23
24 ▾     <a-entity id="sun" geometry="primitive: sphere; radius: 10" material="color: #FfeeCC; shader: flat"
25        light="color:#ffffff; intensity:0.3 type: directional; castShadow:true; shadowCameraVisible: false; shadowCameraNear: 45;
26        shadowCameraFar:100; shadowCameraLeft:-10; shadowCameraRight:10" position="-8 12 -60"></a-entity>
27 ▾     <a-entity light="type: point; color: #ffffff; intensity: 0.2;" position="0 -2 0"></a-entity>
28 ▾     <a-entity light="type: ambient; color: #ffffff; intensity: 0.7;"></a-entity>
29
30 ▾     <a-gradient-sky material="topColor: 137 194 214; bottomColor: 196 227 237;"></a-gradient-sky>
31 ▾     <a-entity id="ocean" ocean="density: 140; depth: 140; speed: 1" material="color: #185b75;
32        opacity: 1; roughness: 1;" rotation="-90 0 0" position="0 -0.6 0" shadow="receive: true; cast: false;"></a-entity>
33
34 ▾     <a-entity obj-model="obj: #island-obj; mtl: #island-mtl" position="1 5 -2.5" scale="15 15 15" rotation="0 -105 0" shadow="cast:true"></a-entity>
35
36     </a-scene>
37   </body>
38 </html>
```

STEP 4

The 3D-island model was made in Google Blocks and can be downloaded here:

vr.google.com/objects/bZ67CTcq7ad.

The download consists of two different files—the .OBJ file that represents the 3D geometries, and the .MTL file which describes the colors used in the model.

We import both of them as items into the <a-assets> tag, which is preloaded and cached for better performance. By giving the asset items unique IDs, we can point to them later from our entity.

<a-entity obj-model="obj: #island-obj; mtl: #island-mtl">

Add the code above in between the <body> tags just below the <a-scene> tag.

CREATE A WEBVR APP IN 30 MINUTES

03

CREATING VIRTUAL REALITY

```html
<!DOCTYPE html>
<html>
  <head>
    <title>14islands webvr tutorial</title>
    <meta charset="utf-8">
    <meta http-equiv="X-UA-Compatible" content="IE=edge">
    <meta name="viewport" content="width=device-width, inital-scale=1">
    <link rel="stylesheet" hreft="/styles.css">

    <script src="https://aframe.io/releases/0.7.0/aframe.min.js"></script>
    <script src="//cdn.rawgit.com/donmccurdy/aframe-extras/v3.8.3/dist/aframe-extras.min.js"></script>
    <script src="https://cdn.rawgit.com/zcanter/aframe-gradient-sky/master/dist/gradientsky.min.js"></script>

  </head>
  <body>

    <a-scene fog="color: #c4e3ed; near: 1; far: 65">

      <a-assets>
        <a-asset-item id="island-obj" src="https://cdn.glitch.com/5052471b-57bb-4fd2-a6ac-d7808c42910b%2Fisland5.obj?1504879913213"></a-asset-item>
        <a-asset-item id="island-mtl" src="https://cdn.glitch.com/5052471b-57bb-4fd2-a6ac-d7808c42910b%2Fisland5.mtl?1504880072617"></a-asset-item>
      </a-assets>

      <a-entity id="sun" geometry="primitive: sphere; radius: 10" material="color: #FfeeCC; shader: flat"
      light="color:#ffffff; intensity:0.3 type: directional; castShadow:true; shadowCameraVisible: false; shadowCameraNear: 45;
      shadowCameraFar:100; shadowCameraLeft:-10; shadowCameraRight:10" position="-8 12 -60"></a-entity>
      <a-entity light="type: point; color: #ffffff; intensity: 0.2;" position="0 -2 0"></a-entity>
      <a-entity light="type: ambient; color: #ffffff; intensity: 0.7;"></a-entity>

      <a-gradient-sky material="topColor: 137 194 214; bottomColor: 196 227 237;"></a-gradient-sky>
      <a-entity id="ocean" ocean="density: 140; depth: 140; speed: 1" material="color: #185b75;
      opacity: 1; roughness: 1;" rotation="-90 0 0" position="0 -0.6 0" shadow="receive: true; cast: false;"></a-entity>

      <a-entity obj-model="obj: #island-obj; mtl: #island-mtl" position="1 5 -2.5" scale="15 15 15" rotation="0 -105 0" shadow="cast:true"></a-entity>

      <a-entity id="shark1" shadow="cast:true">
        <a-entity geometry="primitive: triangle;" material="color:#193447;" position="0 -0.6 -11" rotation="0 0 -30" scale="1.5 2 0"></a-entity>
        <a-animation attribute="rotation" dur="15000" to="0 360 0" repeat="indefinite" easing="linear"></a-animation>
      </a-entity>
      <a-entity id="shark2" shadow="cast:true">
        <a-entity geometry="primitive: triangle;" material="color:#193447;" position="0 -0.6 -13" rotation="0 0 30" scale="1.5 2 0"></a-entity>
        <a-animation attribute="rotation" dur="17000" to="0 -360 0" repeat="indefinite" easing="linear"></a-animation>
      </a-entity>

    </a-scene>
  </body>
</html>
```

STEP 5

As a final step, we'll bring more life into the scene and add shark fins swimming around the island. The fins are simply triangle geometries. To add the animation, we need to attach <a-animation> as a child of the entity that we are animating. We rotate the triangle elements 360° with a linear easing so the speed is constant throughout the animation.

That's it! You just created your first fully immersive WebVR scene. You can now share your Glitch project with friends, by clicking Show Live at the top left of your Glitch dashboard and sharing the URL.

To learn more about 14islands, visit 14islands.com.

CREATE YOUR OWN VR HAND TRACKER

In this guide, you will learn how to create your very own hand-tracked virtual reality controller, thanks to the team at Realiteer. Their RealControl concept uses a proprietary image-recognition and noise-reduction algorithm that runs on your Apple or Android smartphone. When used with their games, you can not only see where you are holding the controller in space, but also use it to interact with the characters on screen.

YOU WILL NEED:

- A VR headset that does not obscure the phone's back camera

- Some cardboard

- Scissors

- Adhesive tape

- A stapler

- Glue

- Template downloaded and printed from www.realiteer.com/diy

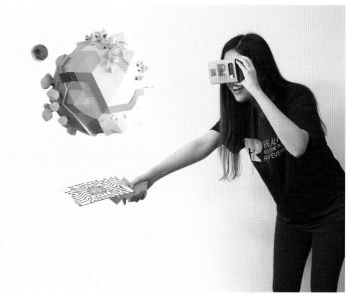

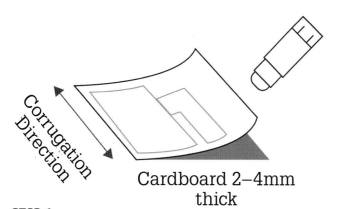

Cardboard 2–4mm thick

STEP 1
Glue the template onto your cardboard.

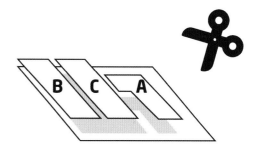

STEP 2
Cut out the pieces along the orange lines.

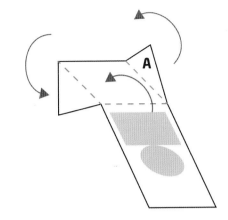

▬▬▬▬▬▬▬	**CUT**
■ ■ ■ ■ ■ ■ ■	**ALIGN**
▬ ▪ ▬ ▪ ▬ ▪ ▬	**MOUNTAIN**
▬ ▪ ▬ ▪ ▬ ▪ ▬	**VALLEY**

STEP 3

Firmly fold the card along the dotted green line downward 90° and the blue dotted line 90° upward.

STEP 4

Align the two patterned rectangles (B and C) together and turn them over. Using tape, stick them together.

STEP 5

Glue and staple the trigger underneath, aligning the blue arrow on part C with the blue arrow on the trigger, and staple where indicated.

STEP 6

Using your right hand, test your trigger by flipping the triangle you folded on the dotted green line upward. This should have the effect of pushing part B up to align with part C, which the software registers as an input.

If the folded triangle of part A is too loose and sliding along Part B, just apply a piece of tape to steady its movement.

PLAY YOUR EXISTING PC GAMES IN VR

03

Trinus is a clever app that allows you to play your existing PC games in a low-cost VR headset such as a Google Cardboard by using the head-tracking sensors in your phone and display streaming. To get started, download the Trinus app to either your iPhone or Android phone, and the Trinus Desktop client. To play wirelessly, your phone must be on the same network as your PC in order for them to connect. For optimum results, you will need a fast router, but if you find the frame rate low, you can connect via USB cable instead.

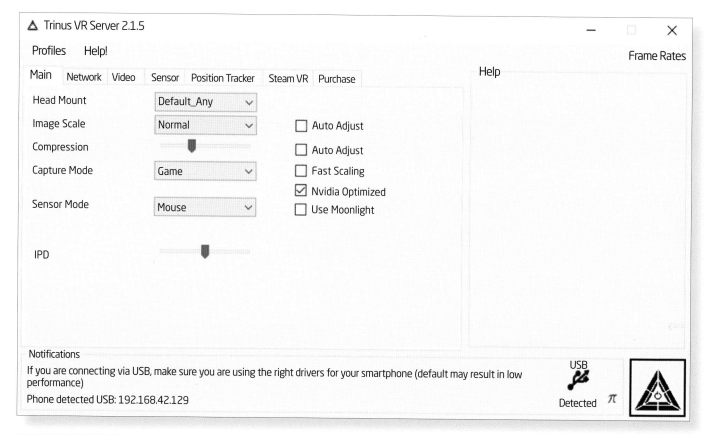

ON THE DESKTOP client, Under Main, choose your headset brand under Head Mount. If your headset is not listed, select Default.

Under Image Scale, choose Normal to start and always use Mouse as the Sensor mode. You can leave the IPD alone.

Under Capture Mode, select Game.

REGULAR PC GAMES

Trinus is great for playing FPS PC games. For instance, those of you who wish to play the classic *Doom* in a whole new immersive way, can do it with this app. Press the Trinus triangle on the app first, followed by the Trinus triangle on the Desktop.

Next, start your game, and you'll see it streaming on your phone. Insert your phone into your headset and you will find you can look around the 3D environment using your head, as you to continue to use your mouse to shoot and WASD controls to move laterally.

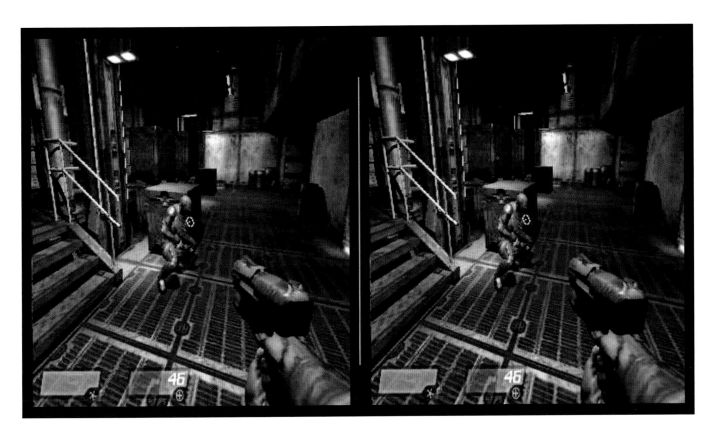

ADDING STEREOSCOPY

Playing regular PC games won't be stereoscopic. Trinus will simply split the screen into two, so it is like playing in front of a large cinema screen. However you can "fake" it with a download called

TriDef 3D. Not all games are supported (for example, *Quake 4* is not) but it supports over 900 PC games and there is a list of compatible games on their website.

03

CREATING VIRTUAL REALITY

Let's say we wished to play *Call of Duty* in stereoscopic virtual reality:

1. Download and install TriDef 3D and select Side by Side in Setup.

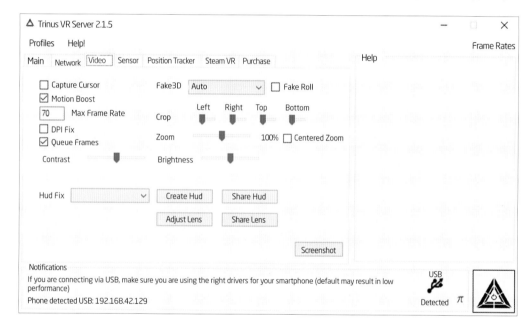

2. On the Trinus Desktop app, go to Video settings and be sure Fake 3D is in Auto mode.

3. When activating TriDef, select Play 3D Games.

4. Select Add Game and import your compatible game.

5. Start up Trinus like you did before and start your game from within the TriDef box. You will now be able to play classic titles like *Call of Duty*, looking around with your head in glorious stereoscopic mode.

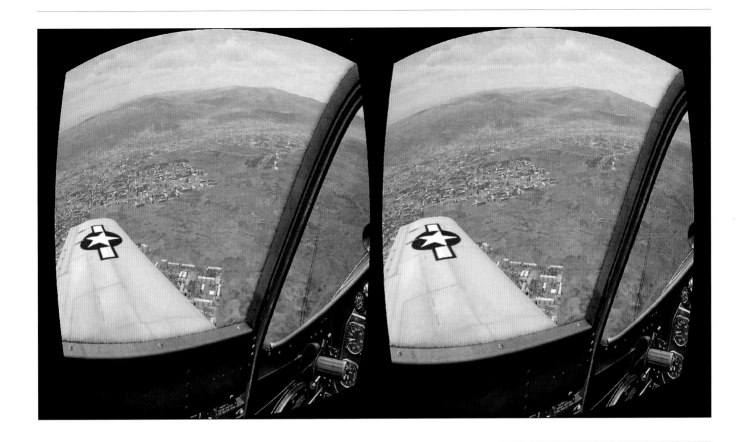

IMPROVING LATENCY

If you find you are experiencing low frame rates, an easy fix is to tether your phone to your computer via USB.

When prompted by your phone, allow the MTP connection prompt, and check the box USB tethering on, turning mobile data off.

Select the USB Detected icon on the Trinus mobile app, and then select the Trinus Triangle on the Trinus desktop client before starting your game as normal.

‹ MOBILE HOTSPOT AND TETHERING

Mobile hotspot
Off

Bluetooth tethering
Share this device's Internet connection

USB tethering
Sharing this device's Internet connection...

VOLUMETRIC VIDEO CAPTURE

360° video, especially stereoscopic 360° video, is great, but it only gives us the perspective from one fixed point (where the camera shot the scene). Some argue that 360° video is not true virtual reality; for that, you would need to see the video slightly change in perspective as you moved your head. This future of video is called volumetric video.

CLOSING ONE EYE, look at something in front of you, like your knee, and rock gently from left to right. You will notice the parallax changes, maybe as your knee obscures your shoe. The reflections of light will also slightly change. This parallax shift is what volumetric video replicates. When we perceive the world around us, our brains create a 3D model of it from a succession of pinhole views, each receiving light from multiple directions and at different focal lengths. Even sitting down, our view is constantly updated to generate a bigger picture.

This is the core principle of how volumetric or 6DoF video works. You can think of a regular camera like recording a single musical track, whereas a volumetric camera captures the individual instruments as separate dedicated tracks, each of which you can listen to and adjust individually.

HYPEVR

The HypeVR camera here was used to shoot a waterfall in Vietnam. Wearing a VR headset, the viewer can move their head to see the perspective of the world change, such as looking behind a barrel. It is bandwidth intensive. Every single frame takes up a whopping 3GB of space.

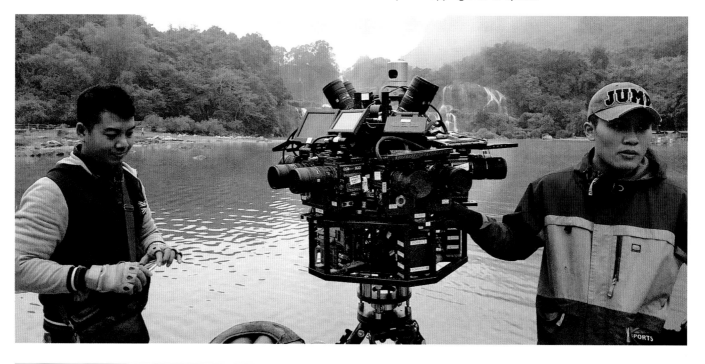

Volumetric video capture methods vary between a handful of companies. HypeVR's beast of a rig consists of 14 x 6K RED cameras shooting at 60fps to capture the textures, which is combined with the depth captured with LIDAR. LIDAR scanners determine depth by bouncing laser lights off objects creating a real-time rendered 3D model of the scene.

LYTRO

Lytro take a different approach to volumetric capture using light fields. Their Immerge system consists of 95 individual high-quality cameras (a 95-element planar light-field array) to capture a 90° field of view. Each camera sees the scene from a slightly different angle and space, capturing the individual lighting reflections from each viewpoint. This translates to a viewing volume of about a meter across (moving side to side) and a step and a half forward and backward. Software generates thousands of synthesized views in between the cameras in a process known as interpolation, with a resolution output of 8K per eye.

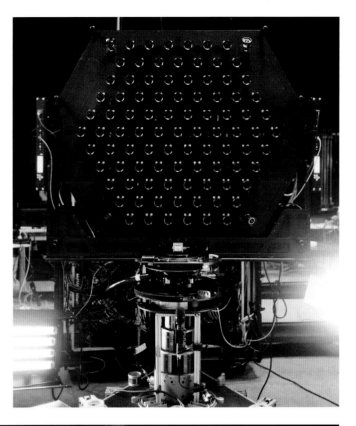

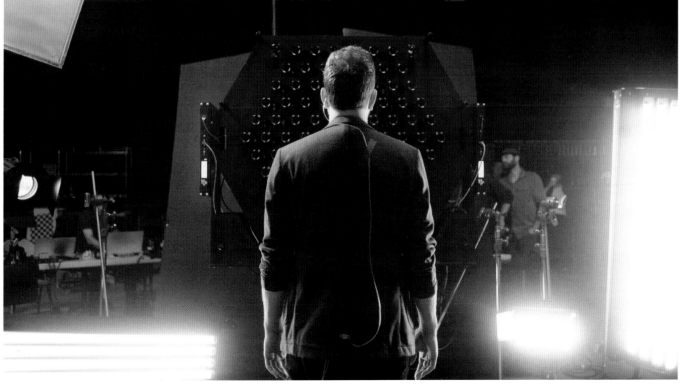

VOLUMETRIC VIDEO CAPTURE

The Immerge was used to shoot the Within original, *Hallelujah*—the world's first VR 6DoF music video. The audience get to experience an intimate connection with composer/performer Bobby Halvorson as he sings the famous song in front of a choir, with direct eye contact and the ability to step closer, shifting side-to-side to see around him. As the experience progresses, the composition builds and envelopes the viewer in music. You even get five different versions of Bobby performing all around you.

On the set, the director Zach Richter was able to view the scene in real time with a touch-screen interface, which displayed the view from all 95 cameras, or a "Center Up" view, which displays the six most extreme angles useful for framing.

Hallelujah was composed with multiple shots taken from various angles that were then stitched together in post-production with the church itself being LIDAR scanned.

You can watch *Hallelujah* in 3DoF mode by visiting with.in/watch/hallelujah.

DATA

One issue with volumetric video is its large data requirements. In the short term, productions like *Hallelujah* can only be viewed at events using specialist hardware, with only a basic stereoscopic 360° version being made available for the home on the Within app.

Even compressed, 1 minute of volumetric video on your phone or desktop can take up to 4GB of space, so the company Reality Virtual, has been using machine learning and other techniques to reduce these file sizes, making it feasible that future 5G services can stream this content.

Volumentric data is captured through a process called photogrammetry, where thousands of regular photographs are taken, by ground-level cameras and drones, which are then stitched together to create a volume. This leads to ultra-realistic scenes (as seen in the picture), with extremely high levels of detail. This is memory intensive, but the company has developed a system that takes high-level dense-point clouds and condenses them into a manageable format.

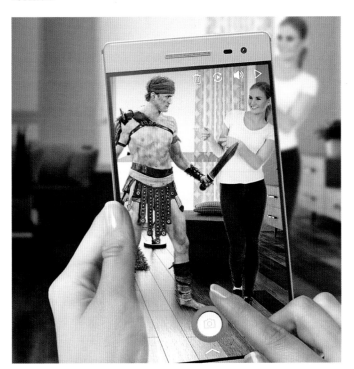

CAPTURING PEOPLE

8i are focusing specifically on volumetric video capture of people, who can be viewed from any angle. In fact, if you are using a room-scale VR headset such as the Vive, you can even walk around them as they perform.

HOLO BY 8i

Vive owners can download a demo app from the Steam store where you can see five themed characters. However, for a taste of volumetric video capture on your phone, you can try 8i's Holo app, available for iPhone and Android, which augments 3D holograms of real people into your real environment.

UP CLOSE WITH SANSAR

CREATING VIRTUAL REALITY

Sansar allows anyone, from novices to professional 3D artists, to create and monetize rich, virtual worlds that others can inhabit. Central to Sansar is the "Atlas," which is a portal to the ever-expanding world of experiences that that range from guided tours to meditation zones.

WHILE MANY WORLDS have been created by talented artists using professional tools such as 3D Studio Max and Maya, you shouldn't shy from creating your own. You can start by working from one of the pre-built templates, modifying, tweaking, and personalizing with its drag-and-drop interface. There is a vast library of "objects" with which to build your world, such as furniture, lighting, sound files, and textures, and you can purchase more assets from the Sansar store. For fine details, the desktop client is ideal, but working in VR mode can be a more intuitive way to sculpt your world, using your virtual hands to place and resize objects. The feeling of moving giant mountains around you as if they are as light as a feather feels incredibly empowering. Once you are happy, you can publish to the Atlas and share access via social media, or keep it private to just you and your friends via a URL link.

Throughout your participation in Atlas experiences, you are represented as a highly customizable avatar (see pages 104–111), and voice recognition analyzes the sound from your microphone to translate it into facial and lip-sync movements when socializing. With access control, there is the opportunity to sell membership and access to worlds you create—for example, a motivational thought-leadership course, entry to a nightclub, or an educational tour.

Why not collaborate too? With its collaboration tools, Sansar allows multiple people to work on a project together, and sell access to it in the future. For example, an entire theme park could be built within Sansar, complete with roller coasters, dark rides, and evening concerts.

MONKEY TEMPLE
In *Monkey Temple* by Anrick and Unit 9, you can share space with others in a temple—an old crumbling relic from times gone by, in which you can enjoy ancient sports, admire the views, find your inner peace, and pay your respects to the simian deities this temple was built to honor.

COLOSSUS RISING
In *Colossus Rising* by Sansar Studios, wind whips through the desolate hills of an ancient battleground where colossal gladiators once fought to the death.

NASA APOLLO MUSEUM

Nasa Apollo Museum by Loot Interactive is a narrative-driven exploration of the Apollo 11 mission. Narrated by actor Peter Cullen, when you enter, you can explore true-to-scale models of the Saturn V rocket, the Command Module, and the Lunar Module, with others or alone if you prefer to tour privately.

UP CLOSE WITH STEVE TEEPS

Steve Teeps is a digital artist who was one of the first Tilt Brush artists in residence at Google. Since then, he has gone on to create stunning Tilt Brush experiences such as *Valerian*, based on the movie *Valerian and the City of a Thousand Planets*, and Marvel Studios' *Dr. Strange*. In *Valerian*, you can explore the aliens from the film, and even scale up to be inside the intruder spaceship. In Marvel Studios' *Doctor Strange*, produced in collaboration with Danny Bittman and Stuart Campbell, you can get close with the classic characters.

Doctor Strange and Valerian are epic projects. Where do you start?

Valerian is a massive scene, so I did some blocking out with 3D models. I worked with the art director and client on the rough 2D sketch/storyboard, which involved an asteroid field, spaceships, aliens, and a floating city from the film. I built a number of asteroids and super simple-ship designs inside of Zbrush, then brought them in as reference meshes. For the city part, I used Google Blocks to create abstract low-poly buildings as references before proceeding to paint.

What were the main challenges?

The main challenge of *Valerian* was to figure out the initial scale of the piece. The client wanted both small-scale navigation and the ability to scale up to stand life-sized in some of the ships. They also wanted to see a variation of characters, and smaller scenes that could be isolated inside this massive painting. *Valerian* and *Dr. Strange* both had a one-week turnaround time that translated to around 80–100 hours of work. For *Valerian*, I was asked to paint the two main characters from the film to see what style I would ultimately do for the piece. This was the quick doodle I sent them (below).

For Doctor Strange and Valerian, did you use any other software?

Cinema 4D is my main 3D package for scene building, rendering, and animation, while I model and sculpt most things inside of Zbrush. Now that VR creative tools have progressed a bit, I also use Oculus Medium, Gravity Sketch, and Google Blocks in this workflow, depending on what I am making.

Here is the render I had to have Disney/Marvel approve for my Dr. Strange painting (below).

What advice would you give someone who is new to Tilt Brush?

The planning part only matters to me when working on large client projects where the end result is being broken up into many different outlets. I learned everything I know from the app just by using it all the time like anything else in the art world. Often when opening Tilt Brush, I do not always have a goal in mind. I think that's part of the fun of creating art in VR. You can start with something small, but scale up later to a massive size, building an entire world instead of a singular object.

EVEN WITHOUT A HEADSET, YOU CAN EXPLORE EACH EXPERIENCE ONLINE!

Marvel Studio's Doctor Strange:
https://vr.google.com/sketches/0V29EJjcSM_

Valerian:
https://vr.google.com/sketches/cguJTVHjO2r

To read more about Steven's work, visit www.steveteeps.com.

CHAPTER 04
AVATARS & AUGMENTED REALITY

THE ART OF THE AVATAR

04

Replicating the human form, with all its nuances of personality, body language, facial expressions, and hand gestures is a challenge, even with big VFX budgets. When we enter social VR and talk to a fellow avatar, we expect confirming nods, eye contact, and lip movements that are synced with speech, so that we can feel a sense of social presence and empathy with our fellow avatar. The good news is the realism of avatars is improving all the time—possibly driven by futurologists' predictions that avatars will one day be our second identities complete with AI-powered personality profiles.

ACROSS SOCIAL VR apps, avatars vary in functionality and realism, from the cartoonish look used by Facebook, to the ultra-realistic characters seen in the app High Fidelity. Currently, you need to generate a different avatar for each app, but ReadyRoom by Morph 3D is taking a one-size-fits-all approach. You can purchase a pre-designed avatar

and sculpt it to your preference wearing a VR headset, which can then be inserted into multiple social-VR apps like VRChat. Their avatars are "persistent" as well, meaning they can grow organically over time. Real-world metrics such as weight fluctuations, hairstyle changes, and your mood can be mirrored by your Morph 3D avatar.

MORPH 3D

These avatars can be made to closely match your real identity, or you may decide for your second persona to be something more otherworldly.

CAPTURING THE REAL YOU

Personalization of an avatar to get it to look like you can be time consuming, so Doob 3D captures people's exact facial features and body shapes in booths around the globe (one of which is shown left). It takes just a split second to get scanned using high-quality photogrammetry techniques combined with proprietary software for photorealism.

Some mobile phone companies allow you to capture facial information. Sony's 3D Creator (shown below) captures datapoints over a few seconds to build up a lifelike model. These can then be attached to animated characters and interacted with in AR. If you are a Samsung S9 owner, you can set up an AR Emoji with a single snap. Machine-learning algorithms then create an animated 3D model of your face which can be customized with different hairstyles, clothes, and so on.

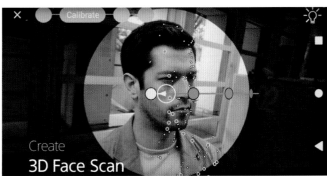

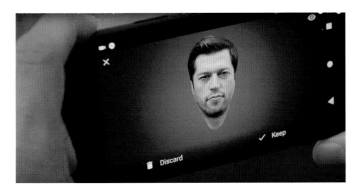

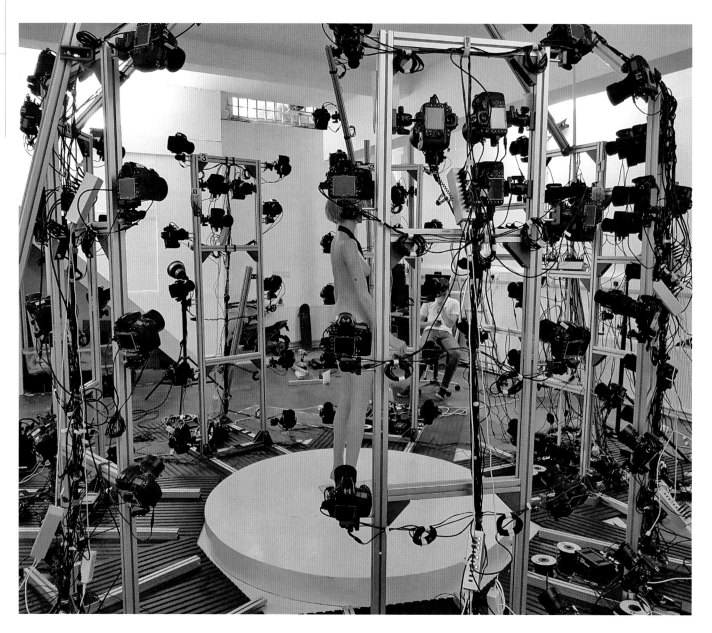

HOLLYWOOD AVATARS

Virtual actors have been used in Hollywood for some time. In *Fast and Furious 7*, Paul Walker's character was reconstructed after a tragic death, and hundreds of digital "extras" walked the deck of *Titanic*.

METAPIXEL

This impressive setup fuses data captured from 105 36-megapixel DSLR cameras to create incredibly detailed human avatars that can be manipulated within a game engine.

In order to fool the viewer that these digital actors are real people, extremely finely detailed texture and movement data is required. One method to do this is through photogrammetry, in which the company Metapixel specializes. As the actor poses in their rig, 105 36-megapixel cameras simultaneously take an image from every conceivable angle. Within just 20 minutes, the data is rendered and stitched together. It can then be applied to a bank of body poses captured by the actor wearing a motion-capture suit, providing the basis for a digital actor that never needs to be paid and can even do their own stunts.

As an insurance policy and for lucrative licensing rights, actors such as Michelle Pfeiffer, Denzel Washington, Gillian Anderson, and David Duchovny have all had their heads scanned—a sort of digital cryogenic freezing process.

THE INTELLIGENT SYNTHETIC

04

Imagine an avatar that becomes you, exploring the metaverse on your behalf, feeding data back to your real life. It behaves and looks just like you, even beyond your death. Tools like Doob3D capture your appearance, but augmenting your personality onto an avatar requires lots of AI, deep learning, artificial neural networks (ANN), and data about yourself.

DEEP LEARNING ALLOWS for autonomy. The neural evolution program MarI/O learned how to play *Mario* without any prior rules or knowledge by using Reinforcement Learning (RL). Likewise, Google's DeepMind used RL to teach a stick-figure man how to run through a virtual parkour course with drops, hurdles, and ledges, without any pre-programming.

UNCANNY VALLEY

Soul Machines is taking ultra-realism and AI even further with ultra-realistic responsive avatars that some even call creepy. Their first project, Nadia, has its own version of a central nervous system that imitates the capabilities of the human brain to make it more realistic.

Deep learning already generates personality profiles in our daily lives. Our search enquiries and social-media activity all contribute to a profile that advertisers can use to target us efficiently. Just imagine how much more advanced that could become by granting your replica avatar consent to monitor your facial expressions through your laptop webcam, your email responses, your voice during phone calls, and your health via wearables. Your replica could use specific sensors to learn what excites you, saddens you, scares you, and relaxes you as it asks you questions, learning more about you over time, so it can better represent you in virtual worlds.

REPLIKA

Replika (shown right) is an AI-powered chatbot program that programmer Eugenia Kuyda developed after losing her best friend Romain Jerome in a tragic car accident. She set about recreating him from his "digital remains," by feeding his messages and emails into a program that would listen and reply to her messages in a way Romain would typically respond. The program is now open to the public. Over time, through text chat, your Replika learns more about you, replicating your personality, and sharing its thoughts with you and others.

One day, AI and deep learning like this could generate your own artificial personality blueprint that your avatar uses to act autonomously, operating in the virtual world even when you are not actively playing. This also opens up the possibility for your loved ones to engage with you beyond your death, as a hologram via devices like the HoloLens (see pages 116–119).

By perpetually retraining their neural networks to adjust to new and ever-changing visual, acoustic, and language cues, your personal AI continually becomes smarter with further use. This future may sound a little scary, but it could make the dream of being in two places at once a reality.

ObEN

Just a selfie and a voice recording—with ObEN, that is enough to create your own personal AI, which can then be injected into an avatar that behaves and looks like you.

LIVING IN THE MATRIX

Movies like *The Matrix* and *eXistenZ* explore the concept of the metaverse—that is, a digital space that replicates, and in some cases surpasses, the physical world. In a way, the metaverse already exists. The internet can be described as a version of it, with its billions of connected websites, in which we can easily hop from one to the next.

THIS PRINCIPLE OF "travel" is the core of any metaverse—it is not one app, it is a collective term for virtual-reality places where we can meet people, go shopping, learn, and be entertained, teleporting from one to another, just how in the real world, we might go to the shopping mall and then get a cab to the cinema to meet friends. In the metaverse, we can do all this without even taking the headset off. Just like the internet and indeed real life, each of these places is created by individuals and companies, constructed around their own value systems and rules of access but following standardized language protocols (like HTML).

As the metaverse grows, Metcalfe's Law will come into place, which dictates networks get more valuable the more interlinked they are. Although there can be no single owner of the metaverse, like there is no single owner of the internet, there are companies laying the foundations and creating protocols such as High Fidelity, Janus VR, and MetaWorld.

Decentraland is a new metaverse platform that is highly linked to blockchain for identity protection and secure methods for people to take financial ownership of their spaces. In it, you can buy 10m x 10m plot of land through the Ethereum blockchain, creating an immutable record of ownership and there is no limit to what you can build upward or downward, from casinos to shopping destinations or an underwater resort.

SEED OF THE METAVERSE?

While the metaverse is expected to grow into vast worlds, Community Garden is taking a more intimate green-fingered approach to sow the seeds of its future. In it, you and others can grow and harvest fruits and vegetables, planting them and nurturing them. Once they have grown, you can sell them for in-game currency to buy things for your avatar and to spruce up the area. It is entirely persistent too, meaning your plants will grow organically over time, even when you are not logged in. Other people's actions will influence the environment, so it is constantly changing. You may not find the world as you left it.

This is just the beginning. The future for Community Garden includes people having their own gardens and being able to make choices that influence how the city looks and functions. For now, the team behind it wishes to get the basics right first. It is powered by Improbable's SpatialOS—a cloud-based system that powers persistent worlds, enabling player actions to have lasting impact, with real change and consequences.

Whether a true virtual metaverse will catch on is impossible to predict and, as explored by Hollywood scriptwriters, the concept generates a lot of questions about the future of humanity. Who governs the laws? What systems would be in place to avoid stolen avatar identity? Who would police hate crimes? Ultimately, it will be the residents of the metaverse to come up with the answers.

COMMUNITY GARDEN & DECENTRALAND

The massive world of Community Garden (above and right) is limitless with its possibilities, where you shape the world around you. Growing every day, there are already thousands of miles to explore. Decentraland (below) is a virtual-reality platform powered by the Ethereum blockchain, meaning users can monetize their own VR experiences. Thousands of investors, artists, developers, and community leaders made the Genesis City auction the largest sale of virtual land in history.

ARKit & ARCore

Apple's ARKit and Google's ARCore are SDKs that can augment virtual objects to surfaces in the real world when seen through the phone's camera, without physical markers.

ARCORE USES A process called concurrent odometry and mapping (COM), and ARKit uses Visual Inertial Odometry (VIO). Each of these uses your phone's camera to detect visually distinct feature points and uses these to compute its change in location. The visual information is combined with inertial measurements from the device's IMU (accelerometers, gyroscopes, pedometers, magnetometers, and barometers) to estimate the phone's position and orientation relative to the world.

This information can then be used as a "virtual camera" that developers can use to place virtual objects on surfaces such as tables or floors, with the correct changing perspective as you move around them. These objects can be "pinned" as well. For example, you could see a virtual spaceship take off from your garden, then take a walk around the block, and see it land in exactly the same place when you returned.

ARCore also features "multiplayer mode," where data can be synced across devices using Google's Visual Positioning System. Users in the same room can then share items in an environment, and one person's object manipulations could be seen by the other device.

The potential of both ARCore and ARKit is huge because they open the potential for mixed-reality applications accessible with simply a phone and a passive adaptor (even a Google Cardboard), without the need for expensive, dedicated mixed-reality headsets.

SEEING YOUR VOICE IN SPACE
Artist Zach Lieberman used ARKit to visualize sounds the user inputs into the phone's microphone. Every pop, click, and "psh" sound is rendered as a 3D waveform floating in space like a cloud. As the user moves the phone back through the clouds, they hear the sound in reverse, as if playing a vinyl record backward.

DRONE HERO AR

In Drone Hero AR, the virtual drone looks like it is part of the real world thanks to ARCore's lighting effects.

THE MACHINES BY DIRECTIVE GAMES

This game has 4K effects and, using ARKit, you can move around and get a better view of the action, such as looking at a tank firing into a cave.

SNAPCHAT

The popular social network app Snapchat has collaborated with artist Jeff Koons to create an augmented reality art platform. In various locations around the world, Snapchat users can hold up their phones and walk around the artist's characteristically balloon-like 3D pieces pinned to real-world hot spots. Powered by their World Lenses technology, the company hopes to attract other artists to the platform.

ARISE BY CLIMAX STUDIOS

This game makes great use of ARKit, as the way you look at the puzzle game is part of the gameplay. In it, you need to guide your hero across an obstacle-filled area and create pathways for him by aligning patterns together through your gaze.

SPEAKING TO HOLOGRAMS

Fans of the 1990 sci-fi classic *Total Recall* might remember a scene when Doug's wife practices her tennis strokes with the aid of a holographic instructor. That may have been a vision of 2084, but thanks to virtual and mixed reality, live holographic people are a reality today.

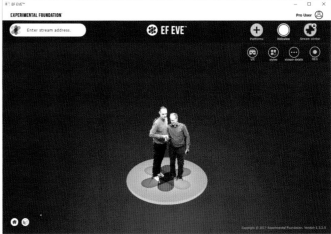

EVE BY EXPERIMENTAL FOUNDATION is a live holographic streaming engine that enables two or more people to speak and interact with each other as live holograms, in real time, regardless of distance, over just a 2MB internet connection.

Two low-cost 3D depth-sensing cameras, such as RealSense or Microsoft Kinects, capture the 3D-point cloud data and textures of a person. The EVE engine then compresses and transmits the data to the recipient wearing a VR headset. If they are wearing a mixed reality headset such as the Microsoft HoloLens, the hologram will appear in the viewer's regular environment, such as their living room.

The applications for fun and socializing are obvious. In the future, it is conceivable that homes could be fitted with depth-sensing technology as standard,

just as telephone connections are today, meaning conversations with holographic projections of our loved ones would be just a click or gesture away.

The technology could also make your living room a stage for famous motivational speakers; private instruction by famous sports stars in a simulated play field or a convenient way to consult with a Doctor.

When linked to social networks, EVE could enable holographic streaming of ticketed concerts, where a singer could appear in your home, captured by depth-sensing cameras on the real stage.

GREEN SCREEN VIDEO

VIRTUAL ENVIRONMENT

TRADITIONAL MIXED-REALITY OUTPUT

MIXED REALITY + HEADSET REMOVAL

REMOVING THE HEADSET

Google have developed a technique that removes the headset digitally so others can see the face of the person wearing it. It involves scanning their face with a camera as they move their head from side to side to capture a large volume of their head. As they follow a tracking dot, multiple 3D images are taken to build up a library of poses and gazes.

When wearing a headset with eye-tracking technology, the most suitable corresponding images that match the gaze of when they were looking at the tracking dot in the same area are displayed, giving the illusion of a see-through headset.

I WANT A HUG!

Humans are social animals, and nothing can replace the comfort of a hug. Hugging your holographic companion might not be that far away. Using EMS (electro muscular stimulation) the Teslasuit has been demonstrated to give a person the feeling of a hug by another person wearing a motion capture suit across the room. This was taken to an international scale, where virtual hugs could be shared between people at the Belarus Free Theatre in London and the Good Chance Theatre in Calais' refugee camp.

MICROSOFT HOLOLENS

The Microsoft HoloLens is a powerful mixed-reality headset that consists of 11 sensors, a super-powerful CPU and special lenses to bring the unreal into the real, but how does it work?

SPATIAL MAPPING

The HoloLens first builds up a 3D model of its surroundings using an inbuilt depth sensor and a process called spatial mapping. Pulses of infrared light patterns are emitted and an infrared camera observes how long each pulse takes to get reflected back. As the speed of the light is known, it can be determined how far away an object is. By understanding the depth of each object in the room, it can be known the depth of where the holograms should be to make it appear they are in the real world, as well as occlusion, for example an avatar's legs being obstructed by a real table. This depth sensor is also able to track your hands in space.

OPTICS

When you look through the HoloLens, you see 3D virtual objects through transparent displays known as holographic waveguides. Virtual reality displays are positioned directly in front of the eyes to cut out the rest of the world. A mixed-reality display needs to show a floating image without the display obstructing the real world.

In the HoloLens, the generated 3D visuals are output from tiny liquid crystal projectors called Light Engines. To transfer the images to the exit point (which the eye looks at) a grating hole above the projector reflects each primary color into the waveguide via very fine ridges. The angle of this reflection is called Total Internal Reflection (TIR); so the light bounces through the waveguide without escaping. TIR is how the light travels through a fiber optic cable without escaping—you only see the dot of light at the end.

As the light travels through the waveguide, it hits a triangle shape, which consists of another series of etched-in gratings that diffracts the light 90° down to a rectangular exit zone. At the exit zone, the ridges change angle again and the light is reflected out to the viewer's eyes. The process is similar to how a periscope transfers an image from one place to another by bouncing the light through a structure.

SOUND/VOICE RECOGNITION

Two speakers situated around the head deliver spatial audio via a technique called Head Related Transfer Function. In the real world, our brain interprets the location of audio sources through the time difference as the sound enters our left and right ears. The HoloLens simulates where the sound is coming from by altering the time at which the sound gets to each ear. With the depth information, it can increase or decrease the volume of an audio source as we move closer or farther away. Four microphones keep tabs on ambient sound and take commands via voice control. For example, you can gaze at a hologram and say "select" or "face me" to turn it to face you.

THE HEART OF THE SYSTEM

At the heart of the HoloLens is the HPU (Holographic Processing Unit) which processes mammoth amounts of sensor data and translates it into smaller and much more manageable chunks, which the HoloLens' GPU and CPU can process at up to one trillion floating-point operations per second.

COMMUNICATING

Skype for HoloLens takes the popular video chat service to a whole new useful level. Let's say you were fixing a light switch. With this app, you can video call an electrician who would appear as a video hovering front of you. Seeing what you can see, he or she can draw circles around what they are describing, which will appear holographically around the real light switch for the user.

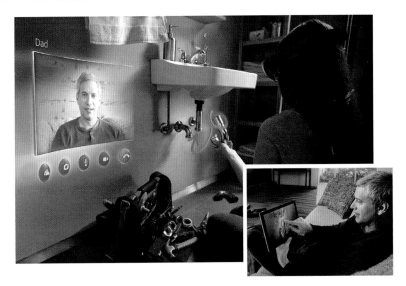

BUILDING FOR FUN

This concept brings Minecraft into the real world, where a Minecraft landscape appears out of a real table which you can walk around, and even peer inside its characteristically blocky windows. Lifting the entire world up with hand gestures reveals a labyrinth underneath of tunnels, caverns, and flowing lava.

VISUALIZATION

The company Fracture MR collaborated with SITA Labs to produce a holographic interface for viewing the real-time operations of Helsinki Vantaa Airport in Finland. Based on the existing system, it uses holographic rendering and gestural interfaces to present and interact with the data in more intuitive ways.

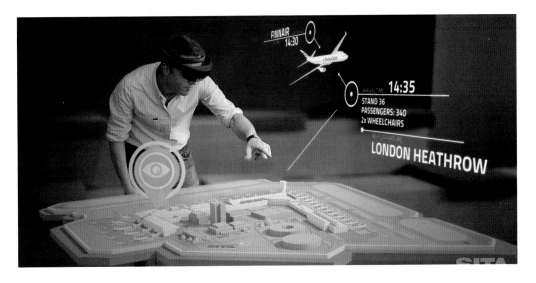

MICROSOFT HOLOLENS

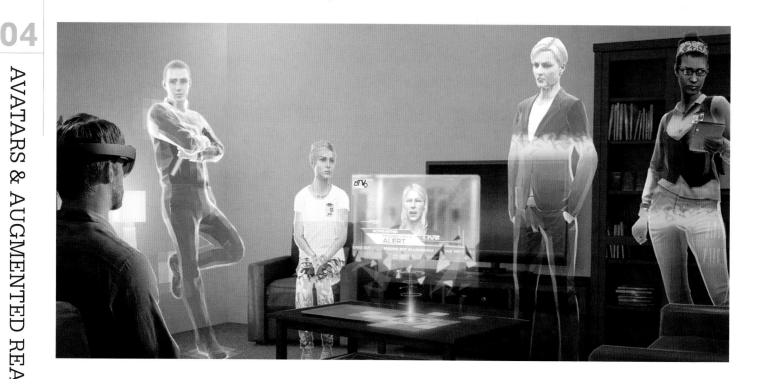

HAND GESTURES

In true *Minority Report* style, you can interact with holograms with your hands, pinching them to change their size or place them in a different location. The HoloLens uses the integrated depth sensor to track the position of the hands and registers if they are in either the ready state (back of the hand facing you with index finger up) or the pressed state (back of the hand facing you with the index finger down). When hands are in other poses, the HoloLens will ignore them.

GAMING

Fragments, by Asobo studio, puts you in the role of a detective tasked with solving a crime inside your own home. When initiated, the HoloLens scans your room and, using artificial intelligence, chooses places to anchor characters and objects for you to interact with, as you explore their memories to crack the case.

For example, a thumb print on a matchbook can be hidden behind your coffee table so you have to get up and find the clue to solve the mystery. The life-sized characters appear to be in your presence and interact with you—for example, sitting next to you on your sofa.

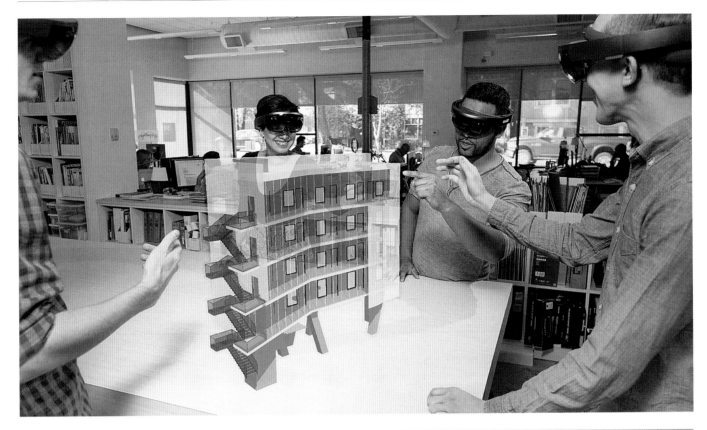

DESIGNING

SketchUp Viewer for HoloLens makes it possible for architects and design professionals to present, collaborate, walkthrough, and evaluate 3D designs with others in real time, even walking inside them.

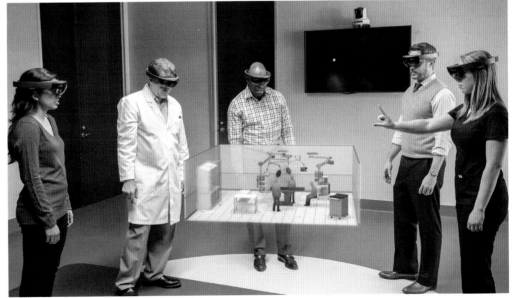

UP CLOSE WITH *HELP* BY THE MILL

Directed by *Fast & Furious* director Justin Lin, *HELP* is a 360° short produced by Bullitt, and content-creation studio The Mill as part of Google's Spotlight Stories, available on Google Play, the Apple App Store, and YouTube.

HELP **THROWS THE** viewer into the center of LA where an unexpected meteor shower crashes into Chinatown, bringing with it a creature who grows from half a foot tall to several hundred feet high by the climactic end. During the thrilling ride, we follow a woman as she is chased by the ever-expanding creature down a subway and out onto the LA River where she finds out what the alien really wants.

Shot in a way that looks like one continuous 5-minute Steadicam sequence, it would have been technically challenging as a regular piece, but when shot in 360°, new methods of filmmaking had to be invented. 81 people worked on the post-production over the course of 13 months, several of which were fully dedicated to R&D and testing, accumulating over 200 terabytes of data and rendering a whopping 15 million frames.

A custom 360° camera rig was developed, which consisted of four RED cameras each shooting at 6K. Each one had a fish eye lens that used a custom post-software calibration to strip out distortion and bring cinema-quality 360° to mobile. The content was shot on blue-screen stages over three days, allowing the live action elements to be blended seamlessly with CG environments, as well as removing the camera out of shot, which was suspended on a cable camera rig.

The Mill developed the world's first ever live action cinema-grade 360° production tool too, called Mill Stitch. This on-set solution produced a real-time rough stitch, allowing immediate control by the director, first AD and DP to work with the actors during takes and see immediate feedback.

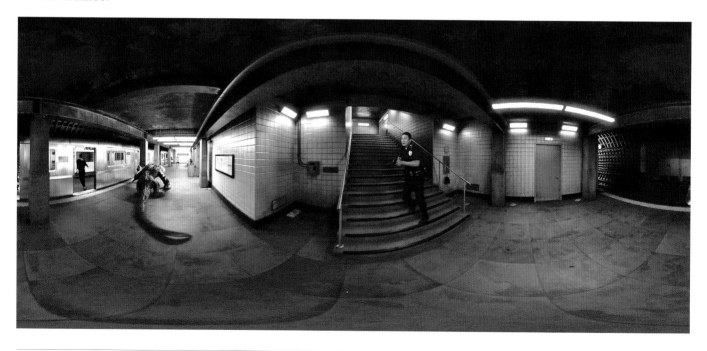

UP CLOSE WITH ALIEN: COVENANT IN UTERO

Alien: Covenant In Utero is a 360° short produced as a collaboration between MPC Film VR, FoxNext, RSA, Q Department, AMD, and the Technicolor Experience Center based on the film *Alien: Covenant*. In it, you see the world through the eyes of a Neomorph as it bursts through character Ledward's stomach with its sights on trapped marine Karine. It was created to market the movie of the same name.

LOGAN BROWN, Head of VR & Immersive Content (Film US) and Moving Picture Company, explains how it was created:

MPC used as many film assets as possible in the creation of In Utero. We enhanced Karine's digi double, used the creature model and texture, and recreated the MedBay set using photogrammetry techniques. Many assets needed modification due to the difference between how they would be viewed in the film and how they would be used in the 360° video.

What was the pipeline for creating Utero?

After we hammered out the concept and agreed upon the script, we went through several rounds of previs in Maya. This was viewed in a GearVR HMD so as to determine user experience concerns that might become an issue in a 360° stereo environment. Using the correct layout from the film set, we were able to place the camera and determine the necessary resolution of the assets and environment. We modeled the space environment and the insides of Ledward from scratch. Then we went to work on the primary and secondary animation for Ledward as well as Karine and the creature. The animation was tricky because we were embodying an Alien creature. We needed to find the balance between realistic alien movement and movement that would ensure that the user would be comfortable during the journey. Blood and gore simulation happened next,

and then we lit and rendered the piece. We used over 5000 machines for a total of about 500,000 render hours. Each frame took about 100 hours to render!

What could mixed reality do for movie marketing experiences?

Mixed reality will offer more than just marketing. We believe MR via location-based experiences will give people the ability to experience their favorite film moments but also new unique moments and storylines with the characters they love. Mixed reality increases presence because users can touch and interact with tangible, motion-tracked props. These experiences also increase the richness of the experience by creating an environment that is conducive to social/group participation.

Are MPC investigating volumetric capture for VR?

Absolutely. While high-quality volumetric video is currently difficult to ship to commercial platforms, the potential for 6DoF video experiences has been proven out and is something that can be offered for location-based experiences and installations where higher hardware specs can be accommodated. Of course, highly interactive, photo-real experiences are the holy grail in terms of film IP—who wouldn't want to have a 1:1 experience with their favorite film character? However, these experiences are still probably years away from a form that most people would find believable and enjoyable.

CHAPTER 05
APPLIED VR

CAN VR MAKE YOU SMARTER?

APPLIED VR

Imagine how much deeper your understanding of quantum dynamics would be if you were an apprentice of Albert Einstein; how engaging a biology lesson would be riding an Innerspace-style ship through the neurons of the human brain; or how memorable the principles of logic gates would be if you were tasked with keeping electrons flowing inside a virtual computer processor.

RESEARCH HAS SHOWN that, after two weeks, we remember 10% of what we read, 20% of what we hear and 30% of what we see. This rockets to 90% for things we do. Learning can be more effective if it is experiential, which includes strategic problem-solving skills and critical thinking, tasks that virtual reality is perfectly suited for.

BROADENING HORIZONS

In Google Expeditions VR, 20 "explorers" are guided by their teacher, all wearing headsets connected to the same router. He or she narrates a tour of 360° images, such as the Great Barrier Reef or the surface of Mars, pointing out areas of interest and asking multiple choice questions. In the AR version, students hold up phones to view augmented 3D objects such as the eye of a Category 5 hurricane or an erupting volcano, walking around them as if they are in the real room. History lessons can be brought to life with reenactments, as in 3DA's Hindenburg VR app which reconstructs the tragedy of the famous blimp, and Espirit Education's multi-user tours of First World War battlefield sites.

Mixed reality will enable a teacher to present virtual 3D models which all the students can see at the same time. Experts in their field such as Stephen Hawking or David Attenborough could be beamed into networked classrooms as real-time holograms, allowing for the students to ask questions as if they were really present.

A future vision of the classroom was created by Abelana VR Productions for the World Science Festival. The teacher was Columbia University Physicist Brian Greene and his students were situated all over the world. Each wore Vive headsets, including Brian Greene, who taught as a robot avatar, and the classroom was in "outer space." The bestselling author built a tesseract (four-dimensional analog of a cube—shown above) to teach string theory, extra dimensions, and the multiverse. The "robot" students were tasked with making their own four, five, even six-dimensional objects, something not possible in the real world.

The future holds a lot of promise to make homework more interesting too. VR educational apps can be gamified in rewarding ways, where if you achieve certain results, special levels are unlocked. AI may also enhance home-based immersive experiences, with a specialist VR teacher avatar able to guide you through various experiences, responding with advice and guidance, according to your input.

EDUCATIONAL APPLICATIONS

Apollo 11 by Immersive VR Education (top right) gives you the chance to join the astronauts through series of missions that took place in 1969. Rome VR by Unimersiv (second from the top) gives you an interactive tour of ancient Rome, exactly as it was centuries ago. InMind VR by Nival VR (second from the bottom) combines education with gaming as you take a miniature-scale adventure in the human mind, in search of the neurons that are causing a mental disorder. Hindenburg VR by 3DA (bottom right) dramatically teaches the story of the of largest flying machine ever built, LZ 129 Hindenburg.

SPORTS & VR

Sports is always at the forefront of cutting-edge broadcast technology, from the first 3D broadcast of Wimbledon tennis, to the planned 8K streaming of the Tokyo 2020 Olympics. It is no surprise that sports rightsholders are exploring how virtual and mixed reality can bring fans closer to their games. Across all platforms, there is a wealth of VR apps offering privileged 360° viewpoints, from pitch to ringside, but the true drama of sport is when it is live, which is what Intel True VR specializes in.

THE PLATFORM DELIVERS fully immersive, VR experiences of live events, captured using a series of stereoscopic pods with up to 12 4K-resolution cameras each, generating up to 1TB of data per hour. The feeds are then sent to the Intel True VR control room, where Intel processors and production engineers turn that data into a virtual reality experience that can be distributed on demand or steamed live. They have been located in MLB, NCAA, PGA, and NFL stadiums and viewers can view like real spectators from the angle of their choice, all live with broadcast commentary. Virtual reality is able to offer unlimited viewing angles too.

Beyond Sports teamed up with Fox Sports to give users the ability to watch replay highlights of the Dutch Football League games from any angle. Players on the pitch were tracked and motion-captured. That data was then used to construct a full volumetric area of the pitch that the viewers could see in 3D 360°, even from a player's or coach's perspective.

INTEL TRUE VR
Sometimes capturing every angle can require the most resilient of cameramen!

The company Virtually Live does something similar for racing. During Formula E events, each car is tracked in real time and ingested into a perfect, fully rendered environment of the real race track, at the same time as the broadcast feed. Because the race is played out in a 100% virtual environment, there are no fixed camera positions, and the viewer can access all areas, from the side of the track to a POV from inside a car they chose, listening to the in-car audio and TV commentary.

It is a concept explored by the VFX production company REWIND, having worked with Microsoft on Flight Deck—a proof-of-concept experience where the viewer can view the air race as a holographic representation, augmented with stats and other visual data. The company sees mixed reality having potential to enhance real spectator sports in stadiums. Renting a pair of glasses, or using technology developed out of ARKit and ARCore, people could enjoy augmented digital overlays, such as a track path of a puck in an ice hockey game or even selecting the halftime entertainment.

BRANDWIDTH

In 2017, Brandwidth was tasked with creating a filmed VR documentary for UEFA to showcase the UEFA Champions League Trophy Tour, presented by Heineken.

The company worked with the Nokia OZO camera to deliver an immersive cinematic experience that gave fans a rare chance to view the trophy and rub elbows with football legends.

APPLIED VR

EXPLORE THE WORLD FROM A DESKCHAIR

"Travel to exotic places" is a common slogan used in virtual reality marketing campaigns, and while nothing can beat the thrill of flying to faraway places, virtual reality can give you a chance to "try before you buy."

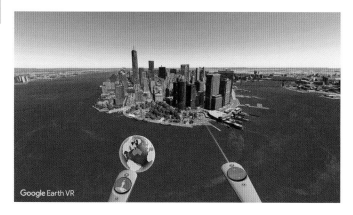

Google Earth VR

Google Earth VR

BY FAR THE most impressive travel-themed app is Google Earth VR for the HTC Vive and Oculus Rift. Synced to the 3D data of Google Earth, you can fly to any destination, peer into the skyscraper windows as if you were a giant, and explore the streets in Street View mode. There is a range of featured places such as the Hoover Dam and the Seattle Space Needle, which you can jump straight into (it really is quite remarkable to stand shoulder to shoulder with such wonders of architecture).

If you wish to explore by yourself, you can rotate the entire earth and then zoom into a location, search an address using the virtual keyboard, or participate in a range of themed tours too, such as "cities" or "water." You can even change the sunrise and sunset by "grabbing" and moving the sun.

SPACEVR

It's not just astronauts who can enjoy live views of our planet. The company SpaceVR operates a low-orbit satellite called Overview 1, the world's first virtual-reality camera satellite to stream spectacular live 360° footage of Earth.

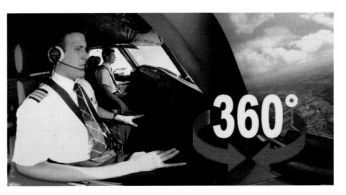

TRAVEL ALBERTA

Alberta's Rockies in Canada are a spectacle of sheer wonder and scale. In this video, you can enjoy a train ride through the region so popular with skiers.

COCKPIT VIEW

Privileged access to a plane cockpit is rare, but in this video, you get to join the cockpit crew of a SWISS Airbus A320 as it takes off from Geneva and lands in Zurich.

JOURNEY TO THE EDGE OF SPACE BY SEEKER VR

This breathtaking narrated video is taken from a camera fixed to a weather balloon as it is released from Earth. You experience the journey as it reaches and travels beyond high precipitation clouds, with a climactic view from 90,000 feet up.

WORLD TRAVELER VR

Part travel app, part game, World Traveler VR lands you in 360° spheres of locations and, using up to eight clues, the challenge is to determine where you are. In the Movie Pack you are tasked to guess which movie was shot in the place you are standing in.

ORBULUS

The king of travel VR apps, Orbulus "orbs" serve as mini portals to a vast range of destinations, which are fused with atmospheric audio effects. Destinations range from Mars to New Year's Fireworks on Hong Kong Harbor.

EUROSTAR ODYSSEY

This app aims to make travel more fun. As passengers speed under the channel, wearing VR headsets, they enter the hidden depths of the sea bed, with exotic sea creatures, sunken treasures, and mysterious seascapes.

DRONES & VR

Drones and virtual-reality headsets are natural companions. In drone racing, contestants wear First Person View (FPV) headsets that wirelessly transmit the drone's camera view to the pilots as if they were in the cockpit, ideal for when the drones are out of line of sight and tricky obstacles need to be negotiated. Drone hobbyists can also benefit from a range of FPV options.

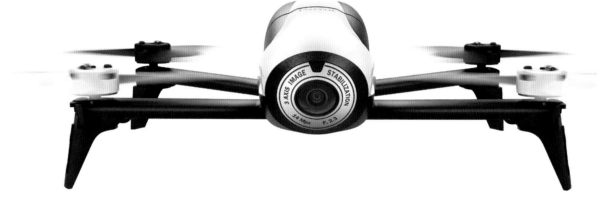

 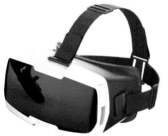

BEBOP

The Bebop 2 FVP bundle from Parrot includes a phone-powered VR headset called the Parrot Cockpit glasses. When used with the FreeFight Pro application, pilots can look around 180°, thanks to the drone's fisheye lens. The Bebop 2 can also be paired with the CloudlightFPV app which augments extra data to your view, such as signal strength, speed and orientation, and a heads-up display.

DRONEVR

DJI drone owners can use the Drone VR app by Appologics to physically control the movement of the camera on the gimbal (all three axes on the Inspire 1 and pitch control for all other DJI drones). It uses your phone's accelerometer to track head movement and steers the drone's camera pan, tilt, and roll position accordingly.

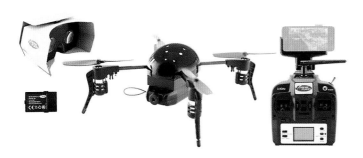

MICRO-DRONE

Even low cost toy drones offer FPV options. The Micro-Drone streams the drone's 1280 x 720 HD, 30 FPS camera live to your phone, split into dual-screen mode, giving you a live cockpit view when wearing the included Google Cardboard.

DJI GOGGLES

Drone Leaders DJI have their own high-end headset called the DJI Goggles, designed specifically for drone video capture. Two 3840 x 1080 resolution displays stream video at 85° FoV—the same as viewing a 216-inch screen from 9 feet (3m) away. You can even share your flight with up to four others, meaning others can join you for the ride in real time.

FLYING EYE

At the top end is the Flying EYE—the world's first broadcast quality, live-streaming VR drone offering 6K of live resolution directly to YouTube and Facebook 360, meaning anyone with a Google Cardboard can experience live flights regardless of where they are in the world.

AUGMENTED-REALITY DRONE RACING

Edgybees has released an augmented-reality drone game compatible with DJI drones and Epson Moverio BT-300 Drone Edition smart glasses.

Drone Prix AR enables pilots to fly their DJI drones through a virtual obstacle course "in the sky" layered on the drone's video feed. You can collect prizes, enter competitions, avoid obstacles in over 30 courses, and even play with others around the world. When playing a multi-player game, each player sees their own FPV. The course is shared by all players, and each player sees the other players represented as avatars.

GET YOUR GROOVE ON IN VR

Virtual reality is revolutionizing how we create and consume music as well as how we can engage with musicians, singers, and DJs. A good place to find 360° music videos is YouTube, which has a dedicated Experience Music playlist. Here you can find *Saturnz Barz* by Gorillaz, which set a record for the highest debut of a VR video in YouTube history, generating more than three million views within its first 48 hours.

LYRA VR

For the creative types, there is also an app for that. Lyra VR is a music-creation tool that fully utilizes the room-scale tracking of the HTC Vive. Using two paddles, you can access Tilt Brush style menus of notes, samples, and edit functions (such as tempo, BPM, and effects).

Where you place your notes in space varies their pitch (the lower they are, the lower the pitch), and by linking them into multiple sub-sequences, controlled by a global BPM, you can trigger rich, multi-layered musical patterns, grabbing notes with your controllers to change their order and organizing your instruments around you.

Some musicians even use it to create live music in real time, streaming to Twitch and at live performances.

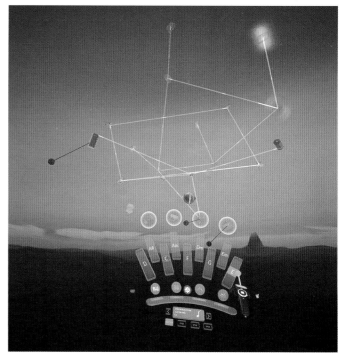

HOLODANCE

Rhythm-based VR games are very popular where music generates the game play. The collaborative multiplayer title *Holodance* gamifies rhythm using beatmaps, where the music is broken down into components that are fired toward you, which you have to block with your fast-moving hands. For example, in Episode 1: Dancing with Dragons each note is fired from the mouth of a hovering dragon.

VIRTUAL MUSIC VENUES

Endless Riff is a virtual music festival platform where you can hang out with your friends who share the same music tastes. The experience starts on your own island where you own a private RV. From there you can teleport to festivals and venues, and see artists up close and live.

GET YOUR GROOVE ON IN VR

HORIZON VR BY HORIZONS STUDIO

Horizons is a series of interactive music journeys, where you control the music, and the music controls the world. You can make an otherworldly jungle come alive with sound, or travel at breakneck speed through a colorful hyperspace.

GROOVR BY PRESENCE LABS

GrooVR is a high-quality visualization app that dynamically changes the world around you in sync to your locally stored or Spotify music.

There is a range of "journeys" such as Mission 9, where you can dance on a reflective boat traveling through a liquid methane river where otherworldly creatures and objects pulse with light in sync to your music.

ADDING DRAMA TO YOUR MUSICAL VR

The Subpac adds an extra dimension to musical VR experiences. The backpack fits to your torso and transfers low frequency bass sounds directly to your body, creating similar sensations to being in a nightclub.

CLUBBING IN VR

With nightclubs around the globe shutting down at unprecedented rates, due in part to the attractive revenues that can be made by converting them into apartments, some nightclubs are looking to extend their brand with virtual reality.

THE RISE OF THE VRDJ

A major player in this space is The Wave VR. Donning an HTC Vive or Oculus Rift, the VRDJ operates a virtual DJ interface, mixing music and manipulating lighting effects, triggering animations and hand controlling spectacular particle sequences, which the clubbers on the dancefloor can see, wearing networked Samsung Gear VRs.

The Wave VR parties can be hosted by DJs entirely remotely too, with others from all over the world participating in the virtual clubbing experiences, interacting with each other, chatting, dancing and taking shared audio/visual trips surrounded by the live light show controlled by the VRDJ. Ahead of time, VRDJs can create their own shows, importing 3D animations, videos, and models, and then manipulate them in real time.

The Wave VR is also developing physical dance clubs devoted entirely to VR, where the DJ and every single dancer is wearing headsets, seeing each other as avatars, motion-tracked by sensors in the venue.

Shows are at least bi-weekly, and to keep informed when and where the next Wave is, sign up to their Facebook page.

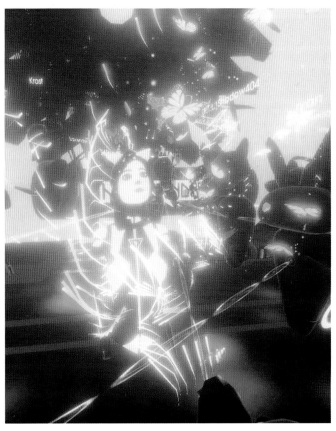

HEAVYGRINDER

In a Wave hosted by Metal-Electronica duo HEAVYGRINDER, clubbers enjoyed a visual feast of infinite sprawling neon-soaked cities, kawaii culture, and dreamlike projections.

BOILER ROOM

Famous clubbing online streaming platform Boiler Room produced VR Dancefloors: Techno in Berlin, a 360° film shot in Berlin's Arena Club featuring a live performance of DJ Fjaak. Within the app, users can navigate through the rooms of the club, view art installations, and interact with their surroundings via "interaction points." The film required 250 extras, and 50 crew members, and used up 70TB of raw data.

THE VR SPA

Virtual reality is not exclusively about high-energy gaming—it can be a very powerful tool to aid relaxation. Wearing a headset is, in itself, quite cocoon-like, shutting out the stresses of the real world, concentrating the mind on the visuals in front of you. This can be especially useful if you are a nervous flyer and want to forget you are 39,000 feet high.

ASMR IS A great way to experience the power of virtual relaxation. Standing for Autonomous Sensory Meridian Response, ASMR YouTube videos attract millions of viewers who experience pleasurable physical sensations, or tingles, from triggers such as page turning, whispering, and personal attention roleplay and there are several 360° ASMR videos available.

One of these is DotCalm by PixelWhipt, a popular 360° video featuring ASMR artist ASMRrequests. In it, you chill out in a futuristic *Blade-Runner*-style apartment listening to the rhythmic drones of the city below. A video projection of Dotty, your 'personal relaxation technician', tells you stories while tapping unusual objects to make you drift off to sleep.

In a world first, three major ASMR artists, GentleWhispering, Heather Feather and ASMRrequests collaborated on a 360° production called The Ke3ys which is available to watch with or without a VR headset on Littlstar.

Others are taking a more 'direct' approach to relax viewers. The Kortex by Fisher Wallace Labs, stimulates the brain when connected to any virtual reality headset. When combined with a meditative app, low doses of pulsed alternating currents are fed through the back of the skull, producing serotonin and melatonin while lowering cortisol (the stress hormone).

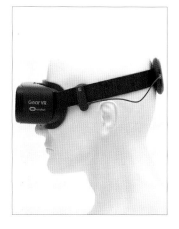

LAND'S END

Each Kortex comes with a copy of the relaxing game Land's End by UsTwo Games and an app that curates meditative content.

GUIDED MEDITATION VR BY CUBICLE NINJAS

This is possibly the most comprehensive guided meditation app available with plenty of relaxing photo-realistic environments, music, and meditations to choose from. It tailors the experience to what mood you say you are in, and the Gear VR version even registers your heartbeat via the infrared sensor on your phone to monitor your destressing progress.

REAL-TIME GAMEPLAY FOOTAGE

DEEPVR

Another add-on is Deep VR. The custom controller measures diaphragm expansion in order to sense deep breathing. This information is fed back to a player wearing a virtual reality headset who sees an underwater environment that gently encourages the player to slow their breath, to sink deeper, and relax.

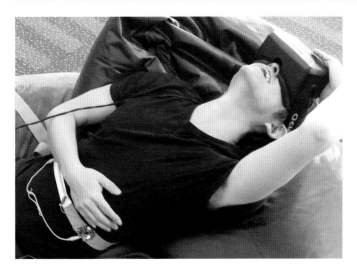

SPOOKING YOURSELF IN VR

Virtual reality has a remarkable ability to scare the living daylights out of people. Even hardcore horror fans can struggle with the jump scares and intense feelings of dread the format serves up. Titles like Resident Evil 7, Alison Road, Stifled, and Narcosis command genuine bravery and nerves of steel.

WITH ITS POWER to put the user into a fight or flight response, developer Flying Mollusk created the horror title *Nevermind*—a biofeedback-enhanced psychological thriller that takes the player into a dark and surreal world within the subconscious minds of psychological trauma patients. Wearing a heart monitor, the player's heart rate is tracked, indicating how afraid he or she is, and the difficulty is adjusted accordingly, challenging the player to calm down to make it easier—easier said than done!

It is not just ghosts and ghouls that can get the heart racing. Thanks to the realism of modern virtual reality, it can very easily trick the mind into believing it is in peril. In Plank Not Included by 4Fun Studio, you are tasked with walking across a plank that gets increasingly higher. It was a concept taken to a more physical level by VR-production company INITION, who created Virtual Vertigo. Complete with physical wind effects to simulate height, and a real plank, the headset wearers had the simple task of walking from one end to the other, accept what they could see in the headset was a sheer drop between two skyscrapers.

11:57 BY WEMERSIVE

Stuck on a chair in a haunted cellar, it soon becomes apparent that you are not wanted there.

GHOST TOWN MINE RIDE

A truly terrifying game that puts you into aghost train that is anything but abandoned.

FACE YOUR FEARS BY TURTLE ROCK STUDIOS

A choice of several hideous experiences for those afraid of heights, spiders, and confined spaces.

VR TO GET IN SHAPE

With an ongoing obesity crisis, and its costly ramifications, the fitness industry is looking at ways to incentivise people to exercise. The Virtual Reality Institute of Health and Exercise, independently assesses VR games in a controlled environment, with the aim of publishing the results through a fitness rating system, having found many VR apps are more effective at burning calories than a treadmill. Some gyms are already experimenting with the installation of virtual reality exercise equipment.

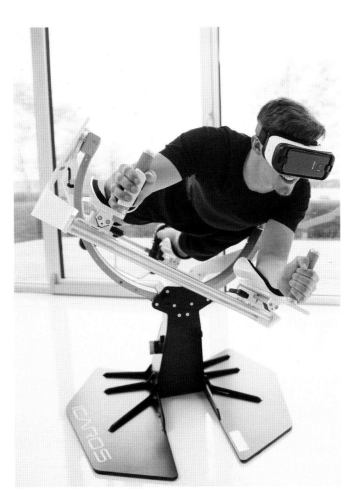

THE FUTURE OF immersive exercise is set to get a lot more interactive and personalized, especially with mixed reality and AI-powered personal instructors that train you as a hologram in your own home. He or she could be a fitness celebrity that tailors the exercise to you in real time, using data from fitness wearables, reducing or increasing the tempo according to your heartbeat, and even providing you nutritional advice as well as Dancemania-style lessons. You could even stand next to your future self if you reach target, adding further motivation.

Of course, the headsets will need to become as small and lightweight as prescription glasses to make all this truly mainstream, but with Facebook revealing such a patent-pending system, working out may become a pleasure rather than a chore.

ICAROS

The Icaros is a VR exercise machine that delivers a core workout by making it seem like users are flying and deep-ocean diving. Already deployed across hundreds of gyms around the globe, its three-axis system gets the user to engage their abdomen, back, and leg muscles to tilt the device to navigate while flying or diving, using a hand controller to fire at targets during the game.

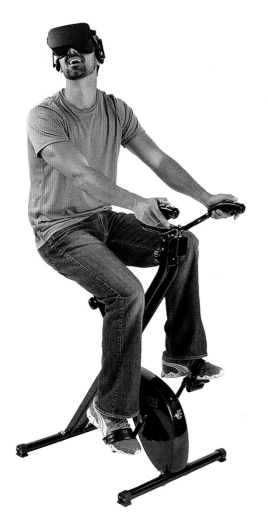

VR WORKOUT ROUTINE

A testament to virtual reality's fitness credentials is Tim Donahey (AKA u/leppermessiah1 on Reddit) who took part in a 50-day challenge playing four Vive games in an hour:

- *Audioshield*: **10 min**
- *Thrill of the Fight*: **20 min**
- *Holopoint*: **20 min**
- *Holoball (cooldown)*: **10 min**

The result was a weight loss of **14.4 lbs**!

VirZOOM

For the home, VirZOOM upgrades existing exercise bikes into multiplayer-gaming VR-arcade machines with the VirZOOM Bike controller. Your bike becomes a chopper in *River Run* where you dodge missiles and take out military targets, a giant robot where you enter live Mech battles with others around the globe in *Thunder Bowl*, and a horse in *Jailbreak!* where you capture gambits by lasso. VirZoom can also be integrated with Fitbit and Strava to set personal goals and track your distance, heart rate, power usage, and average speed.

BLACKBOX

Black Box takes fitness to a positively futuristic scale with their VR boutique gyms that use virtual reality to gamify exercise where your speed, strength, and endurance help you win. Virtual-reality experiences are attached to an integrated cable pulley system for resistance training synced to the on-screen VR visuals, which include scenes of urgency and perceived danger to encourage the user to push past their normal boundaries. AI is used to monitor the user's progress and adjust the workout to fit a planned trajectory of an ultimate workout goal.

VRCADES

If you do not own a VR headset, VR arcades (or VRcades, as they are known) offer the chance to see what all the fuss is about, with state-of-the-art headsets and room-scale experiences. HTC is building over 5000 VRcades where people can pay a fee to play a vast library of Vive titles. IMAX VR Centers operate a similar model using Star VR headsets. Patrons can choose from a range of single- and multi-player titles, complete with haptic feedback. IMAX is also creating exclusive titles like *The Mummy Prodigium, Strike* based on the movie.

THE VOID IS a chain of VRcades that host multisensory VR experiences. Players wear a custom-made dual-screen 2K 180° FoV headset called The Rapture, which features heat and wind generating elements, for simulating an explosion or draft from an open door, for example.

The Void has partnered with movie companies too. In *Ghostbusters Dimension*, you collaborate with 10–12 other people who appear as fellow Ghostbuster avatars tracked in space by multiple cameras. Communicating with each other via microphones, guests use their proton guns to battle tiny pink poltergeists and living stone gargoyles in a 40th floor New York apartment before a climactic sequence featuring the infamous Marshmallow Man. As objects are hurled, the haptic suits simulate the impact. Mist is synced to generate the sensation of a ghost whooshing past. The gun recoils when firing proton pulses, and vibrating floors add body shocks and rumbles during explosions. The Void plans to increase the power of the haptic vests so guests feel genuinely concerned to be shot for "real, almost punishing feedback."

HOLD ONTO YOUR HEADSETS

For the ultimate fusion of real-world extreme sensations and the creativity of VR, many theme parks are "upgrading" their rides with virtual-reality visuals. In fact, that process is what the company VR Coaster specializes in.

They worked on the enormous Acrophobia drop tower ride at Six Flags Over Georgia, where thrill seekers wearing Samsung Gear VRs fire robotic creatures and cyborgs as they ascend. When the ride drops for real, in the virtual world, the riders race toward a giant cobweb where their score is revealed.

On the Galactic Attack roller coaster, riders can even select their path though the experience at specific points on the track, choosing between flying through an asteroid field or through an alien spaceship.

On the Sky Rocket roller coaster in Kennywood, riders can switch lanes and interact with others. When bumping into the vehicle of a virtual competitor, riders lose a place; if they overtake them, they gain a better position. It is a real racing experience, but with all the intense g-forces and airtime moments of a roller coaster ride.

05

APPLIED VR

UP CLOSE WITH THE COUPLE WHO SPENT 48 HOURS IN VIRTUAL REALITY

VR headset companies suggest taking a break every 20 minutes, so what would 48 hours in VR do to someone psychologically and physically?

BRANDWIDTH HEAD OF Innovation Dean Johnson and Coventry University professor Sarah Jones decided to find out, despite the warnings that it could be dangerous. They ate, slept, worked, and played in VR over the 48 hours, clocking up 36 hours of standing, traveling 20 miles, and walking 41,381 steps across 30 experiences. Dean had previously set a 24-hour record but decided to up the ante, convincing Sarah to join him in a 48-hour exploration of the misconceptions of virtual reality such as motion sickness and it being for gaming only.

Dean reflected: "We tested several games, but the boxing sim *The Thrill of the Fight* was the most surprising and intense. Even though the opponents were cartoon characters, it was utterly believable. The experience convinced me of the huge potential for virtual reality to make exercise and sports training more fun and effective, training your muscles and improving your reflexes."

Aside from games, the couple tried several physical experiences wearing headsets, even when moving from venue to venue.

"Arriving at the go-karting center, we both climbed out of the car completely disoriented after watching 360° content on the way. Because the car was controlling where we were looking, it made us feel incredibly sick." said Dean.

During the go-karting, they wore Gear VRs in video passthrough mode (where you see a monoscopic view captured by the phone's camera). They noticed how quickly their brains adjusted to the stimulus, managing to go full speed without hitting anything.

Dean also bravely put himself forward to explore the concept of virtual reality pain management. Wearing a Gear VR he got a tattoo of an Apple Mac, while playing arcade title *Gunjack*. 10 was the benchmark for the pain without the headset. This dropped down to 6 while playing, with his heart rate dropping to an average 74 bpm in the headset (103 without).

For the finale, Dean went on an airplane wing walk. "I managed to get on the wing and then my Samsung phone decided it wanted a software update. There I am, in the middle of an airfield with no connectivity and no way to use the phone." chuckles Dean. He ended up wearing the Gear VR without the phone, seeing the environment through thick blurred lenses for the entire duration, strapped to the plane. It was so blurred at one point he had thought he had taken off while he was still on the ground!

Overall, apart from when watching 360° content in a car, the duo did not suffer much motion sickness. Dean's nose did become bruised and his vision became noticeably blurred for weeks afterward, but there were no long-term effects.

CHAPTER 06
REFERENCE

RESOURCES

COMMUNITIES

There are meetups in most major cities where people can get together to discuss virtual/mixed and augmented reality developments. To find your nearest, visit www.meetup.com and search virtual reality.

STAY UP TO DATE WITH THE LATEST NEWS:

roadtovr.com

uploadvr.com

vrfocus.com

virtualrealitytimes.com

ORGANIZATIONS & EVENTS

vrs.org.uk

thevrara.com

vrukfest.co.uk

vrworldevent.com

vrlo.co

vrworldcongress.com

FUNDING

investvr.co

BFI: http://www.bfi.org.uk/supporting-uk-film/film-fund

UK Games Fund: http://ukgamesfund.com/

Virtual Reality Capital Alliance: http://www.vrvca.com/

The Virtual Reality Fund: http://www.thevrfund.com/

VIRTUAL-REALITY DEVELOPMENT SOFTWARE

Unity

Unreal Engine

A-Frame

First Parallel

ZapWorks

TOP ANDROID AND iPHONE VIRTUAL-REALITY APPS

Gold Miner Go! Cardboard	Cedar Point VR
Hidden Temple VR	VR Liftoff
Bomb Squad	Galaxy Golf VR
Whispering EONS	Lost Contact
Hardcode	Destiny Zero
Cardboard Crash: Sundance Ed.	Quake VR Multiplayer
Bandit VR	The Lost Future
Guardian VR	A Time in Space 2
Sketchfab	View-Master Into the Labyrinth
Return Zero	
Space Stalker	World's A Mess
VR Noir	Android's Dream
Cleanopolis	Apnea
Titans of Space	Salvaged VR
InBody VR	

GLOSSARY

Active presence
An immersive state that is reached as a consequence of using a handheld tool/device (peripheral) within a VR experience.

Agency
The capacity of an entity (a person or other entity) to act in, and influence, an artificial environment.

Augmented reality (AR)
In augmented reality (AR) the visible natural world is overlaid with a layer of digital content.

Avatar
A virtual representation of the experiencer within the virtual world.

Butterfly effect system
The butterfly effect system is a storytelling mechanism for managing complex narrative structures where actions from the experiencer can have a direct influence on how the narrative plays out.

CAVE
A CAVE (cave automatic virtual environment) is a virtual reality environment made up of between three and six walls that form a room-sized cube. Projectors display a virtual world onto the interior walls of the CAVE

and are then controlled by the movement of an experiencer from within the CAVE.

Collision detection
Detection that virtual objects have intersected, sometimes triggering haptic or visual feedback for the experiencer.

Duck test
A colloquial name for a method of testing if an experiencer has reached a state of presence, by monitoring their behavior when threatened by a virtual object.

Embodied presence
Acknowledging the existence of your body within a virtual-reality experience.

Experiencer
Experiencer is another word for "user" or "player."

Eye tracking
The ability of a head-mounted display (HMD) to read the position of the experiencer's eyes versus their head.

Eye tracking is particularly useful for informing VR analytics, where the developer wants to better understand what content the experiencer is focused on in a specific scene or view.

Field of view (FoV)
The view that is visible to the experiencer while rotating their head from a fixed body position. The average human field of view is approximately 200 degrees.

Gaze
The direction the experiencer is looking in.

Gaze-activated content
When content (e.g., the way actors within a scene behave, or the narrative) is directly impacted by the experiencer's gaze.

Gesture
A form of non-verbal communication through the body—typically the hands or head—that, when tracked by a motion-sensing camera attached to a computer, can be interpreted as movement and mirrored in virtual reality.

Gestures that are directly reflected in the virtual world also help to enforce a sense of agency, as well as contributing directly to presence.

Global agency
Interactivity where the experiencer's actions could yield some sort of outcome or have a consequence on the narrative

Haptics
Haptic technology simulates the sense of touch through the sensation of pressure (usually on the hands via a glove).

This helps to support agency by enabling the experiencer to control virtual objects or sense physical forces within the virtual environment. Haptics are a significant component in peripherals.

Head-mounted display (HMD)
A set of goggles or a helmet with tiny monitors in front of each eye to generate images seen by the wearer as three-dimensional.

Head tracking
The ability of a head-mounted display (HMD) to monitor the position and orientation of the experiencer's head through tracking.

Hotspot
An interactive spot within the artificial experience that reveals more content or options. Hotspots can be animated and are often shown as a glowing orb.

Immersion
A psychological sense of being in a virtual environment.

Latency
The time delay or lag between activating a process (change in input from the experiencer) and its accomplishment (the visual effect).

High-latency can lead to a detached experience and can also contribute to motion sickness / dizziness.

Locomotion
Refers to the process of moving from one place to another.

This is most commonly used to refer to movement within the virtual environment (e.g. how an avatar navigates the virtual world) but can also refer to movement outside of the virtual environment (e.g. how the experiencer navigates the real-world while in a virtual experience).

Mixed reality (MR)
Mixed reality (MR) is similar to augmented reality (AR), except virtual objects are integrated into the natural world.

For example, a virtual ball beneath your desk would be blocked from view unless you bent down to look at it.

Occlusion
The obscuring or hiding an object from view by the positioning of other objects in the experiencer's line of sight.

Peripheral
A device that helps enhance a virtual reality experience by enabling greater immersion within the virtual world.

The most common VR peripherals are gloves or controllers (e.g. the Oculus Touch) that look to mirror the experiencer's innate movements and help to facilitate better active presence.

Player modeling
Refers to the process of learning a model of the experiencer's individual differences (e.g., preferences, play style, etc.)

Positional audio
Audio that is triggered based on the position of the headset.

For example, in a crowded scene, the experiencer would be given the ability to choose which conversation they listen to based on where they are looking.

Redirected walking
The name given to a technique used to extend the possible size of a virtual reality environment by imperceptibly rotating the virtual scene without the experiencer being aware.

Room scale
A design paradigm that allows users to move freely within a room-sized environment while partaking in a virtual reality (VR) experience.

Signposting
Environment cues with the added purpose of helping the user interpret the virtual environment.

Swayze effect
The sensation of having no tangible relationship with your surroundings despite feeling embodied in the virtual world.

Virtual reality (VR)
Virtual reality (VR) places the experiencer in another location entirely. Whether that location has been generated by a computer or captured by video, it entirely occludes the experiencer's natural surroundings.

Virtual-reality sickness
The feeling of general discomfort caused by experiencing virtual reality.

Symptoms can include headache, nausea, vomiting, drowsiness, and disorientation.

WebVR
WebVR is an emerging technology that aims to present virtual reality content in traditional web browsing interfaces.

Yaw
Rotation around the vertical (y) axis.

06

REFERENCE

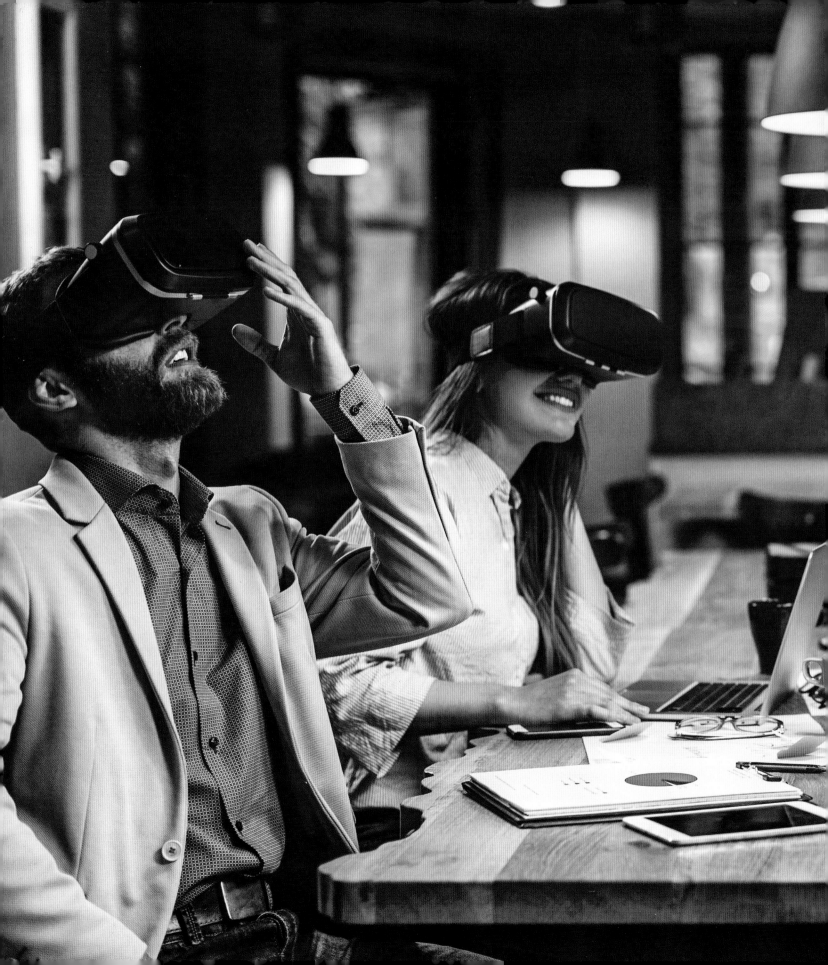

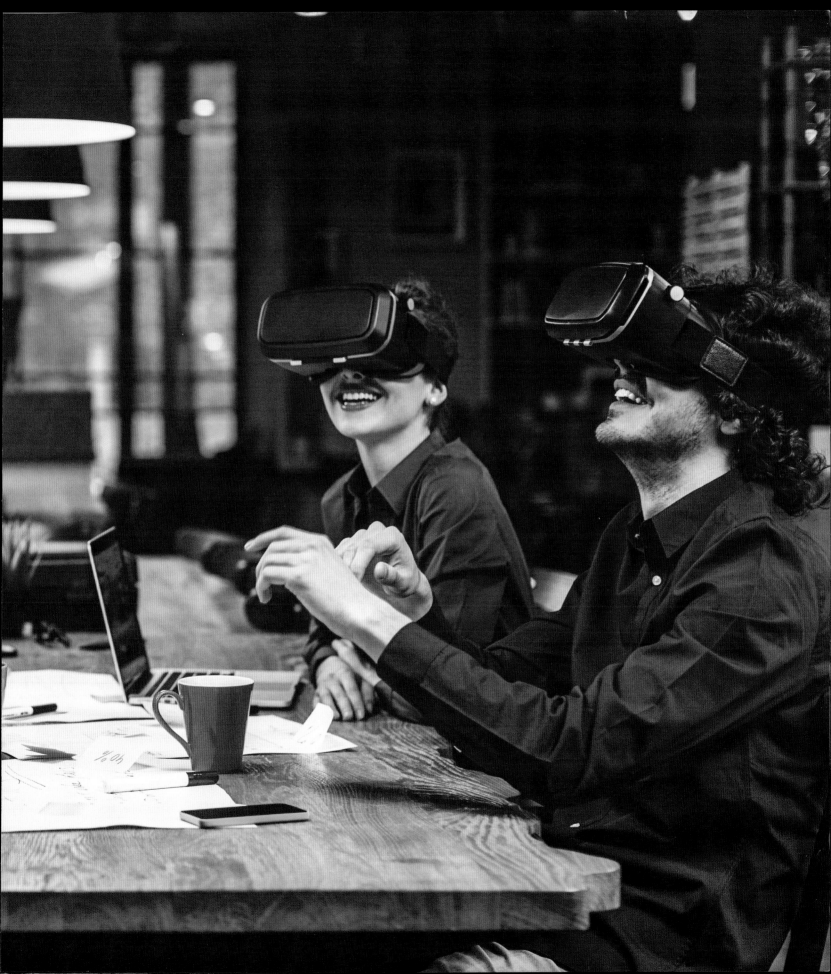

ACKNOWLEDGMENTS & PICTURE CREDITS

Writing this book has been a wonderful experience; throughout the process, it has been an absolute pleasure talking to so many pioneers, risk takers, visionaries, and highly talented people who are at the forefront of this incredibly exciting medium. I would never be able to thank everybody who has assisted me in the creation of this book, but it goes without saying that every company mentioned over the past 160 pages has been wonderfully supportive and collaborative in supplying images and setting up interviews with me.

However, I would like to say some special thanks! Animator Joe Daniels and the ANIMVR team spent a lot of their time working on the video guide made especially for this book, and I hope the readers will be equally inspired as I was when animating in VR! The 14islands team is incredibly busy, but still collaborated with me on the webVR tutorial—a great challenge to write in just six pages! There is Steve McCarthy from the VR Glossary who gave permission to include parts of his wonderful VR resource in this book, and the teams at The Mill and MPC who went to tireless efforts to set up interviews and supply such wonderful behind-the-scenes images. A big shout-out to the Sansar team too, who put me in contact with some great people and gave me fantastic assets, as did the *USA Today* team whose schedule is packed, but were still able to find time to contribute for the Up Close feature with David Hamlin. John Gaeta Executive Creative Director at ILMxLab has further inspired me as to what virtual reality can bring to creativity, as did "VRtists" Shaung Chen and Steve Teeps whose Tilt Brush talent has got me drawing in my spare time (though I am a million pixels away from their standard).

Overall, thank you for everyone who supported me on this book. I would like to end with a special acknowledgement to two people in particular, the first being Andy Millns, the founder of INITION, who hired me back in 2012. It was a wonderful company to be part of (and if you want any VR production work, be sure to give them a shout—they are world class) and thanks to him, ultimately this book came about. That leads me onto my second special thank you, and that being Adam Juniper at ilex and author of *The Complete Guide to Drones*. He watched a video of me during an INITION VR Meetup, and got in touch. I had never written a book before, but he showed a lot of faith in me and gave me a wonderful opportunity to write about what I love.

PICTURE CREDITS

AndreaObzerova / iStock: 2; HTC: 4T, 16R, 31TL, 31TR; Oculus: 4M, 7, 13, 17TL, 17B, 34TR, 76TR, 76BR; Microsoft: 4B, 18, 25B, 117-119; Insta360: 6; max-kegfire / iStock: 8-9; Danny Smythe / Shutterstock: 10TR; View-Master: 10BR; Dr. Jonathan D Waldern: 11TR; Sega: 11BR; USC Institute for Creative Technologies: 12; bilwissedition Ltd. & Co. KG / Alamy Stock Photo: 13B; Google: 14, 15TL, 32B, 54 (3 images), 64-65, 115T (4 images), 126 (3 images), 130TL, 130TR; Samsung: 15TR, 46L; ; Warner Bros: 15BL; Zeiss: 15BR; Sony PlayStation: 16L; Magic Leap: 19TL; Sulon Q: 19R (4 images); Avegant: 19BL; Mira: 20; Amber Garage: 21; Richman21 / iStock: 23; Wearality: 25T; Starbreeze: 25M; Nvidea: 26; Triangular Pixels: 31BL, 31BR; Radiosense: 33T; Pico: 33B; Leap Motion: 34BL; Noitom: 34BR; Fove: 35TR, TM; Emteq: 35B; VR Touch: 36TR; Ultrahaptics: 36 MR, BR; Hardlight: 37T; Mixed Realms: ML, MR; Cerevo: 37B; Refugio3D: 38TR; 3dRudder: 38BL; Vrgo: 38BR; RotoVR: 39; Rovr: 39; Cyber Interface Lab, Univeristy of Tokyo: 39B (3 images); Dimension Gate: 42T; *USA Today*: 42C, 42B, 55T; Felix & Paul Studios: 43L; Paramount: 34R; Keven Kohler: 43B; Tudor Antonel Adrian / Dreamstime: 45; 360Fly: 46R; Insta360: 47TL, 47TC; Ricoh: 47TR; Acer: 47BL; Sphere: 47BR; Lucidcam: 48L; Lenovo: 48R; Jaunt Inc.: 50L, 50R; GoPro: 51TL; Nokia: 51TR; Yi Technology: 51BL, 51BR; Sennheiser: 52BR; 3DIO Sound: 53TL; Facebook: 53TR, 77TL, 77BL; OSSIC: 53B; Discovery VR: 55B; Netflix: 56TL; Hulu: 56R (3 images); Samhound Media: 57T; CineVR: 57T; Visualise VR: 58L, 58R; Magix: 60-63; Roundme: 66-67; David Hamlin: 68-69; JP Wallet / Shutterstock: 70-71; Joe Daniels: 73; Shaung Chen/Shu4n6: 75 (3 images); SteamVR: 75L; vTime: 77TR, 77BR; nDreams: 78TL; Steel Crate Games: TR; Cortopia: 78BR; Destruction Crew: 79T; Tom Weirc: 79MR; Against Gravity: 79B; A-frame: 80; Interactive Arts/Nexus Studios: 81TR, 81TM; Konterball: 81BL; Arturo Paracuellos: 81BR; 14islands: 82-87; Realiteer: 88-89; Trinus: 90-93; HyperVR/Intel: 94; Lytro: 95-96; 8i: 97; Anrick / Unit 9: 98BL; Sansar Studios: 98BR; Loot Interactive: 99 (3 images); Steve Teeps: 100-101; PeopleImages / iStock: 102-103; Morph 3D: 104L, 104R; Doob 3D: 105T; Sony: 105B (4 images); Metapixel: 106-107; Soul Machines: 108; ObEN: 109T; Replika/Eugenia Kuyda: 109B; Community Garden: 111T, 111M; Decentraland: 111B; Zach Lieberman: 112T, 112B; Neuston: 113TL; Directive Games: 113TR; Snapchat: 113M (4 images); Climax Studios: 113B (2 images); Experimental Foundation: 114L, 114R; Teslasuit: 115B; Minecraft: 117M; Fracture MR / Sita Labs: 117B; Asobo studio: 118; The Mill: 120-121; MPC Film: 123; franz12 / iStock: 124-125; Abelana VR Productions: 127TL; Immersive VR Education Ltd.: 127T; Unimersiv: 127–2nd from top; Nival VR: 127–2nd from bottom; 3DA: 127B; Intel Corporation: 128T, 128B; Virtually Live: 129T; REWIND: 129M; Brandwidth: 129BL, 129BR; SpaceVR: 130B; Travel Alberta: 131TL; SWISS Airbus: 131TR; SeekerVR: 131TML; World Traveler VR: 131TMR; Orbulus: 131BL; Eurostar: 131BR; Parrot SA: 132T; Appologics: 132B; Micro-Drone: 133TL; DJI: 133TR; Flying EYE: 133BL; Edgybees: 133BR; Lyra VR: 134 (3 images); Holodance: 135T; Endless Riff: 135B; Horizons Studio: 136T, 136B; Presence Labs: 137T, 137M; Subpac: 137B; The Wave VR: 138, 139TL, 139TR; Boilder Room: 139BL; 139BR; PixelWhipt / ASMRrequests: 140T; GentleWhispering / Heather Feather / ASMRrequests: 140M; Fisher Wallace Labs: 140B; UsTwo Games: 141T; Cubicle Ninjas: 141M; DeepVR: 141BL, 141BR; Flying Mollusk: 142T; INITION: 142B; WEMERSIVE: 143T; Ghost Town Mine Ride: 143M; TR Holdings, Inc.: 143B; Icaros: 144; VirZOOM: 145T; Black Box: 145B; The Void: 146; VR Coaster: 147T, 147B; Dean Johnson / Sarah Jones: 148-149; golero / iStock: 150-151; Magnolija / iStock: 153; pixelfit / iStock: 158-159